Anita Rich & Robin Dallenbach

PORTRAITS
OF NASCAR®

First time ever...
see inside NASCAR's
homes, lives, and families

The authors have made every effort to ensure that the information within this book is accurate; however, they cannot be held liable for any errors, inaccuracies or omissions.

DEDICATION

Wally, Jake, Wyatt, and Kate Dallenbach

Bob and Dorothy McCall

Suzanne McCall

Wally and Peppy Dallenbach

Patty Moise

Esther Simon

Jody, Ashley, and John Rich

John, Julie, Jonathan, and Julia Hart

Karen and Jeremy Warner

Rachel and Derwyn Jones

Vikkii Erato

Nilgun and Keith Graham

Jackie Hall

Lynn Lowe

Cindy Wares

Linda Yusman

Margaret Tyrrell

Susan Farmer

Arthur, Kay, Alison, and Shirley Parken

Carol and Mike Pritchard

Emilie Knight

Karen Ashworth

Larry and Crystal Howard

Bob and Barbara Speranza

Paul Butler

Jack and Betty Hickey

Kate and Robby Lawrence

Kris and George Braman

In loving memory of
John Herbert and Evelyn Mary Hart
George Walter and Priscilla Alber Rich

Micah Rhea Arrants

CONTENTS

ACKNOWLEDGMENTS....................VI

FOREWORDVII

INTRODUCTIONVIII

INTRODUCTIONIX

JOHN ANDRETTI1

GREG BIFFLE7

DAVE BLANEY11

CLINT BOWYER17

KURT & KYLE BUSCH20

RICHARD CHILDRESS.................25

WALLY DALLENBACH.................31

BILL DAVIS........................37

DALE EARNHARDT JR.................43

RAY EVERNHAM51

BILL FRANCE57

ROBBY GORDON63

JEFF GREEN67

KEVIN HARVICK....................73

MIKE HELTON79

JIMMIE JOHNSON87

BOBBY LABONTE.............................91

MARK MARTIN.............................97

CASEY MEARS.............................103

JOE NEMECHEK.............................109

BENNY PARSONS115

KYLE PETTY119

SCOTT RIGGS123

JACK ROUSH129

ELLIOTT SADLER.............................137

TONY STEWART143

MARTIN TRUEX JR.147

BRIAN VICKERS153

RUSTY WALLACE.............................157

MICHAEL WALTRIP.............................161

HUMPY WHEELER169

VICTORY JUNCTION GANG CAMP.............................175

WAM (WOMEN'S AUXILIARY OF MOTORSPORTS)179

ABOUT THE AUTHORS182

ACKNOWLEDGMENTS

We would like to thank our families for their understanding and support; Jody Rich for all his help with the text and copy, Shannon Wright of Whirlwind Creative for understanding the vision, and Don Cox for pointing us in the right direction.

We would especially like to thank Betty Jane France, Mike and Lynda Helton, Kyle and Pattie Petty, Mark and Arlene Martin, Bill and Gail Davis, the Women's Auxiliary, and all of the drivers, owners, wives, children, and families who allowed us into their lives.

FOREWORD

When I first heard about this project, I liked the idea of it. NASCAR has always been about the fans, and our fans are the greatest. The idea that we would be able to give them a chance to see us in a more personal way seemed a natural thing.

One reason I am pleased to see *Portraits of NASCAR* published is that it is a good historical record of our current era in racing. Having grown up with my dad and uncle in the racing world has given me a great sense of the history of our sport. So many great personalities have been included in the book, and it really presents an in-depth picture of our sport, and the people who make it up. This book is truly the first of its kind.

Finally, and most importantly, I am pleased that Victory Junction Gang Camp and the Women's Auxiliary of Motorsports are recognized in this book. They do so much good in our communities. I hope you have a chance to help them in the future, and I know you will enjoy this work as much as I do.

—Casey Mears

INTRODUCTION
from NASCAR Illustrated

Access.

Getting to know our heroes up close and personal is every NASCAR fan's Holy Grail. To some degree, we've come to expect access, even taking it for granted, throughout the world of sports and entertainment. We take off our shoes—so as not to scuff the Italianate marble floors—and stroll through celebrity homes via MTV's *Cribs*. C-Span gives us more peeks behind the curtain of Washington's slow-moving political machine than any of us really need. *Access Hollywood* delivers on its title promise, showing us the lives and times of the rich and fabulous.

But even in NASCAR, where the biggest stars are unusually committed to offering the most access of any major sport, fans are rarely invited to share their lives beyond the track.

As Executive Editor at *NASCAR Illustrated*, I am charged with taking our readers behind the scenes. It is no easy task. But when it's done right, the results are a magical trip into an otherwise secret world.

With *Portraits of NASCAR*, Anita Rich and Robin Dallenbach got it right. The creative duo behind the book was invited by their subjects to join the family, so to speak, capturing images of NASCAR's biggest names relaxing at home.

Portraits of NASCAR is more than a collection of photographs. Looking through it is a uniquely intimate experience, brought to life in dynamic, moving black-and-white photos. Because a picture is always worth a thousand words, the pages are unfettered by a lot of text. The photographs speak for themselves, each telling its own tale.

—Michael J. Fresina
Executive Editor, *NASCAR Illustrated*

INTRODUCTION
from the Authors

We live in a fast time. Each week we see the glamorous front view of our favorite drivers, owners, and personalities at the track.

This is a unique book of black-and-white photography, very limited in text. The focus is on the other important parts of the drivers' and owners' lives—the wives, children, and families of these men—and how they perceive themselves. We see the beauty and closeness of the motorsports family, as shown in their photographs and comments, that bring strength and support to these incredible men.

This book captures today as it is happening—this moment in time—in the motorsports world.

As the project has grown, so has the excitement within the racing world, extending from drivers to racing team and track owners. The charities included in the book, and the causes they represent, are dear to everyone in the motorsports family. The Victory Junction Gang Camp and the Women's Auxiliary of Motorsports help so many people, in so many different ways, throughout our community.

Come on in, and make yourself at home.

JOHN
ANDRETTI

Birthdate: March 12, 1963
Birthplace: Indianapolis, Indiana
Residence: Mooresville, North Carolina
Family and Personal: Married to Nancy; father of Jarrett, Olivia, and Amelia; nephew of open-wheel legend Mario Andretti; cousin of Michael Andretti

Career Highlights

1997: First NASCAR Sprint Cup Series victory, Pepsi 400 at Daytona
1994: First driver in history to race in both the Indianapolis 500 and Coca-Cola 600 the same day
1983: USAC Midget Rookie of the Year

I think that life is short, so it is important to take advantage of every opportunity along the way. Never forget to laugh with your loved ones!

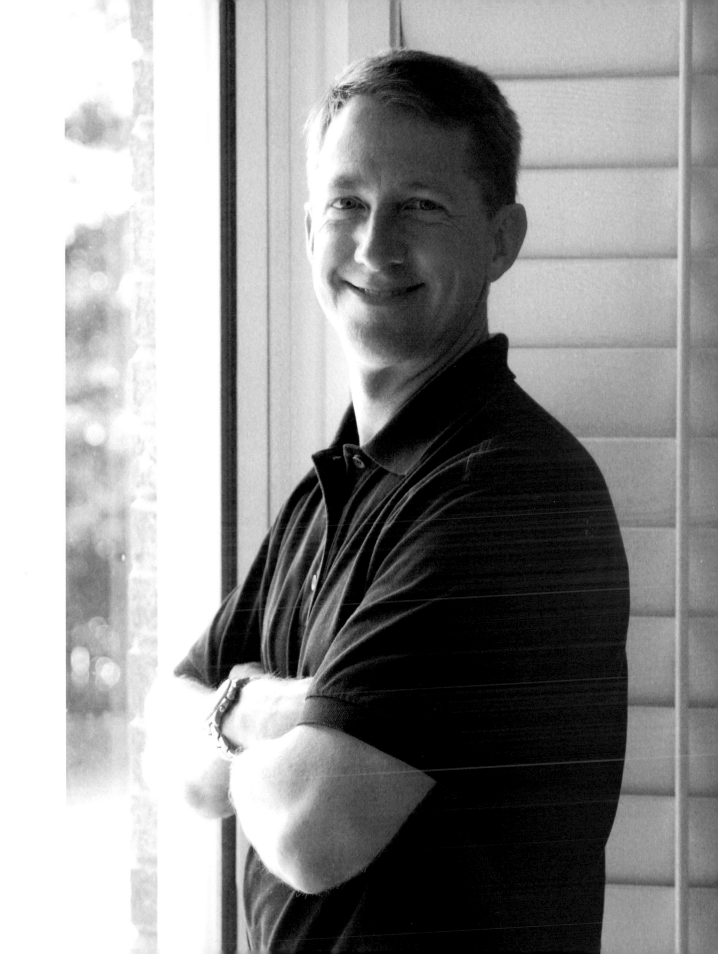

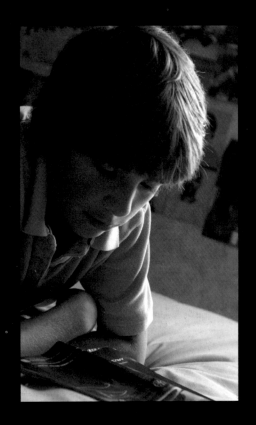
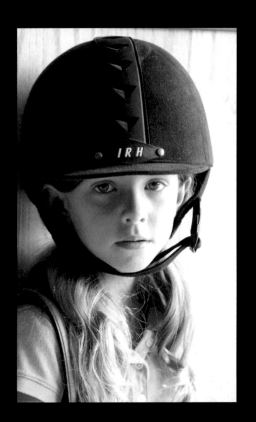
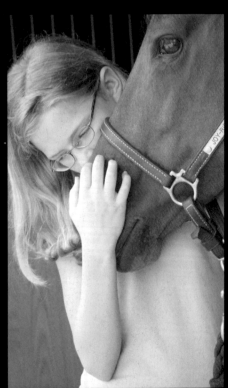
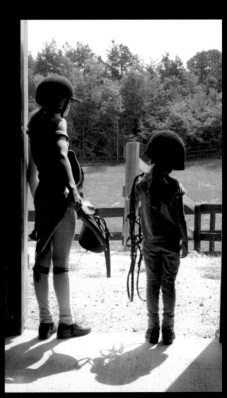

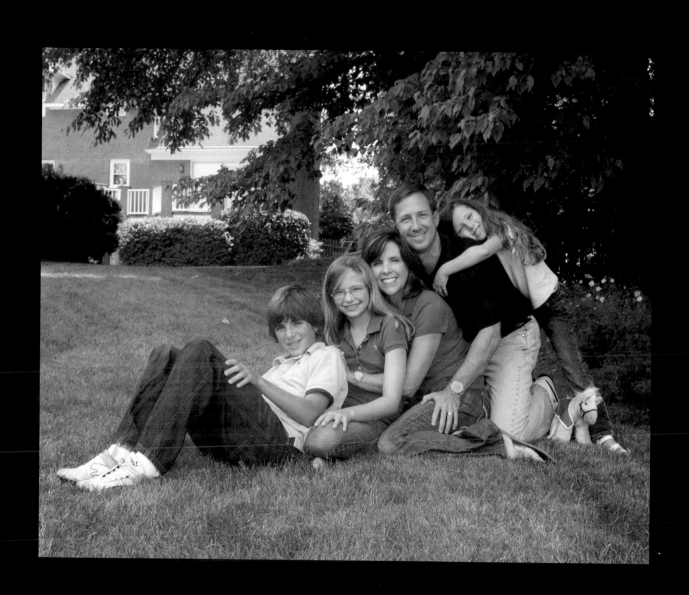

GREG BIFFLE

Birthdate: December 23, 1969
Birthplace: Vancouver, Washington
Residence: Mooresville, North Carolina
Family and Personal: Married to Nicole

Career Highlights

2005: Most wins (6) of any driver in NASCAR Sprint Cup Series
2003: First NASCAR Sprint Cup Series victory, Pepsi 400 at Daytona
2002: Won NASCAR Nationwide Series, becoming first driver to win both NASCAR Craftsman Truck and NASCAR Nationwide Series championships
2001: NASCAR Nationwide Series Raybestos Rookie of the Year
2000: NASCAR Craftsman Truck Series Champion
1998: NASCAR Craftsman Truck Series Raybestos Rookie of the Year

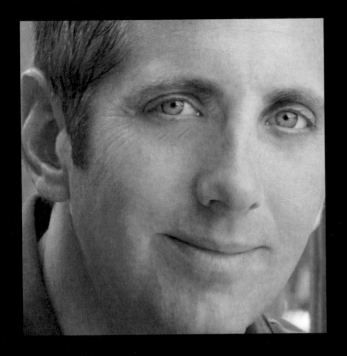
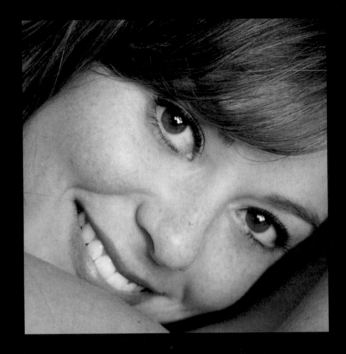
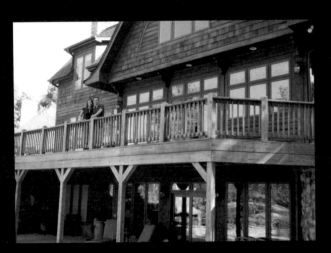
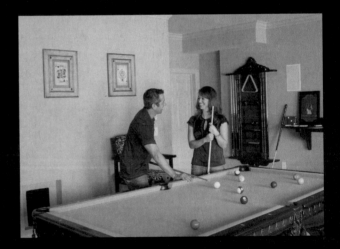

Nicole and I made this home for each other. We met during my first year in the NASCAR Craftsman Truck Series when Nicole was in college. Our dogs, Gracie and Foster, are a big part of our family.

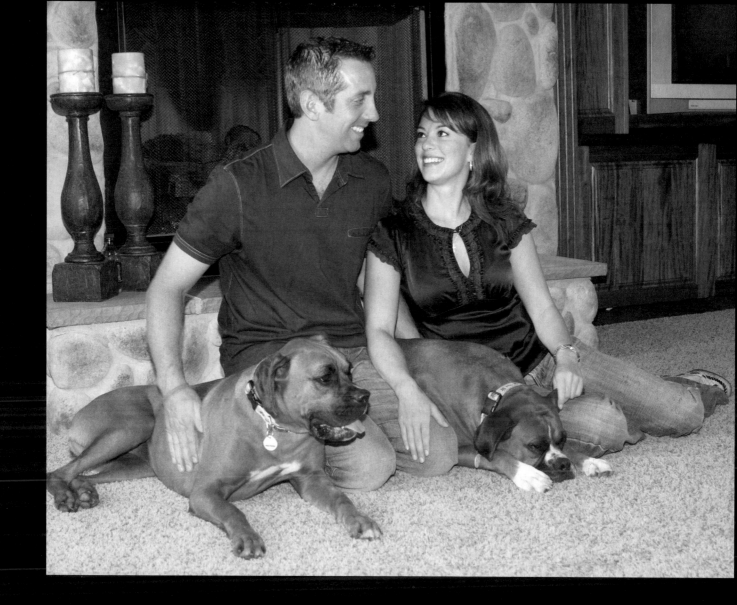

DAVE
BLANEY

Birthdate: October 24, 1962
Birthplace: Hartford, Ohio
Residence: High Point, North Carolina
Family and Personal: Married to Lisa; father of Emma, Ryan, and Erin; owner of Sharon Speedway in Hartford, Ohio

Career Highlights

2007: First driver to earn a pole for Toyota (at New Hampshire)
1995: World of Outlaws Sprint Car Champion
1984: Youngest driver (20 years old) and first rookie to win USAC Coors Light Silver Bullet championship

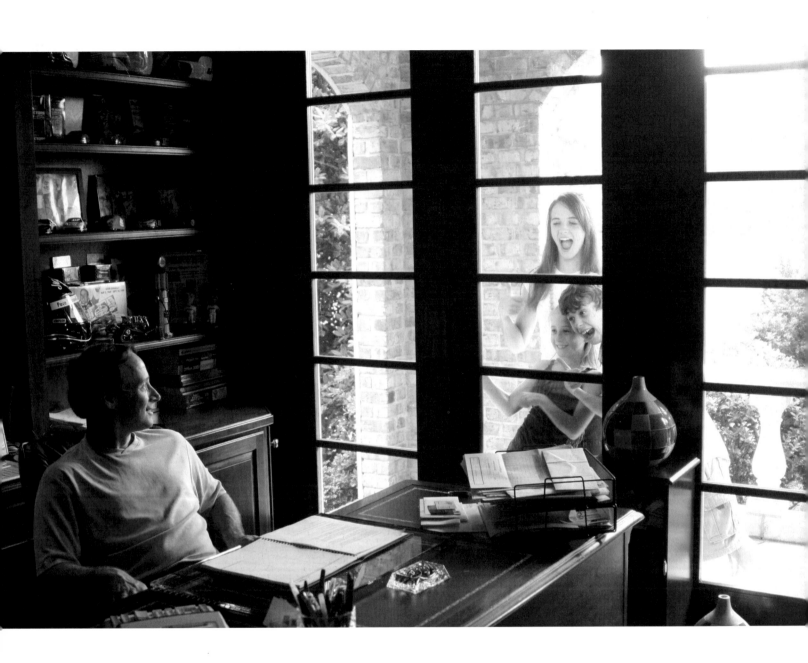

Lisa and I cherish each other, and the kids fill our days with laughter and love.

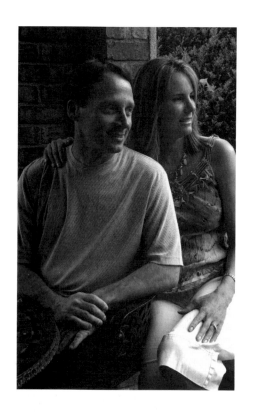

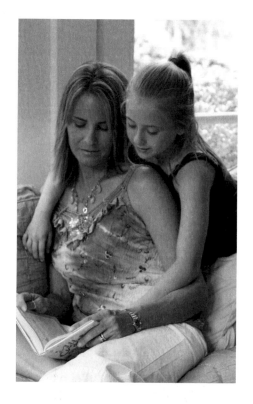

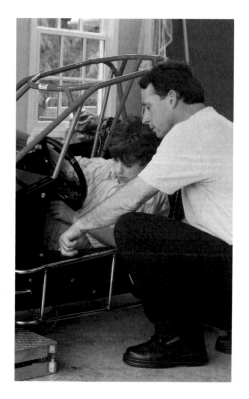

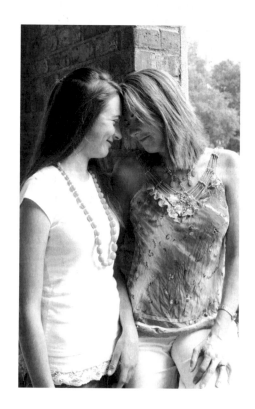

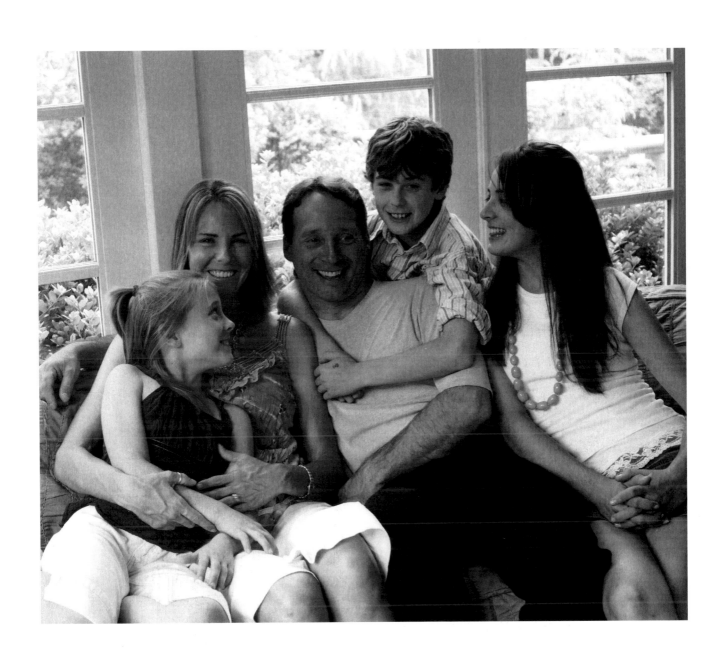

CLINT
BOWYER

Birthdate: May 30, 1979
Birthplace: Emporia, Kansas
Residence: Clemmons, North Carolina
Family and Personal: Single

Career Highlights

2007: First NASCAR Sprint Cup Series victory, Sylvania 300 at New Hampshire
2005: Finished 2nd in points, NASCAR Nationwide Series
2002: NASCAR Weekly Series Midwest Region Champion

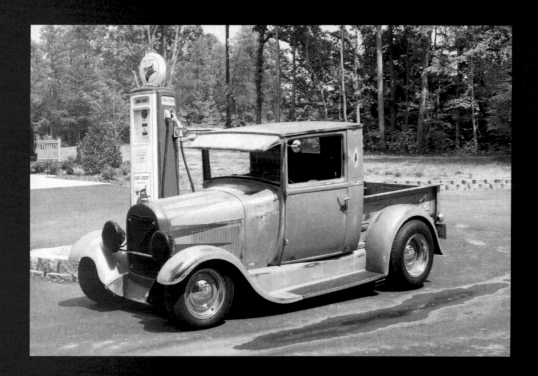

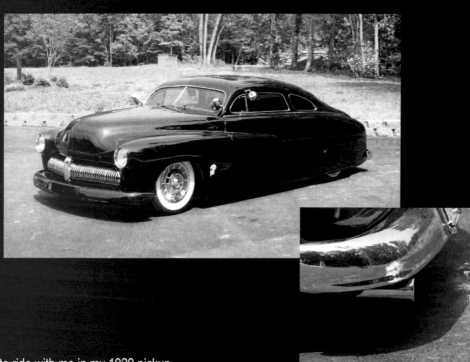

Ulla loves to ride with me in my 1929 pickup truck, which I bought in Joliet, Illinois, and often drive between my home and the sleepy town of Welcome, North Carolina. This 1949 Mercury, with its chopped top, was my first big purchase.

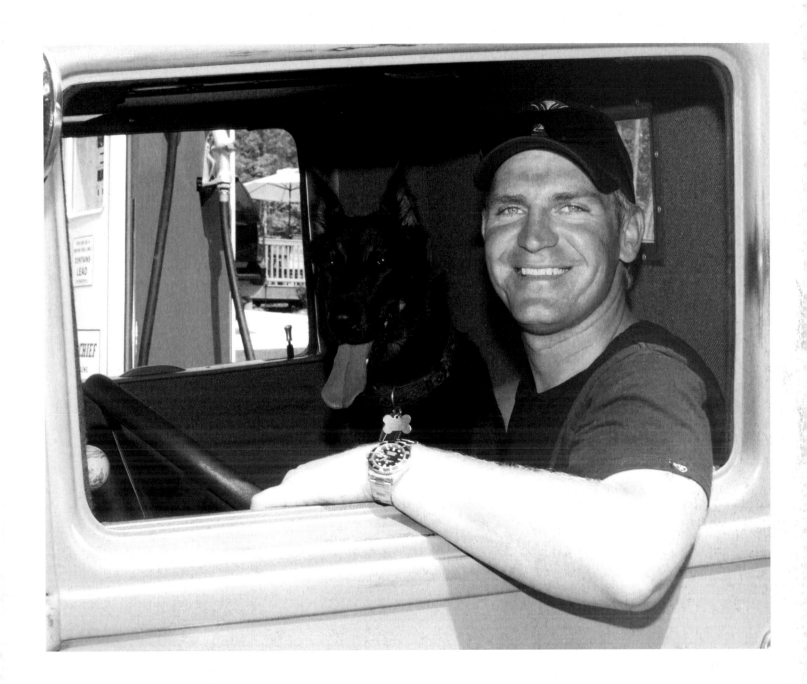

KURT
BUSCH

Birthdate: August 4, 1978
Birthplace: Las Vegas, Nevada
Residence: Concord, North Carolina
Family and Personal: Married to Eva; older brother of Kyle Busch

Career Highlights

2004: NASCAR Sprint Cup Series Champion
2002: First NASCAR Sprint Cup Series victory, 2002 Food City 500 at Bristol
2000: NASCAR Craftsman Truck Series Raybestos Rookie of the Year
1998: Southwest Touring Series Rookie of the Year

KYLE BUSCH

Birthdate: May 2, 1985
Birthplace: Las Vegas, Nevada
Residence: Mooresville, North Carolina
Family and Personal: Single; younger brother of Kurt Busch

Career Highlights

2005: NASCAR Sprint Cup Series Raybestos Rookie of the Year
2005: First NASCAR Sprint Cup Series victory, Sony HD 500 at California
2004: NASCAR Nationwide Series Raybestos Rookie of the Year

It's good to be close to family when we are always so far from home. Dad has always believed in us. I know Kurt will never show me his hand, but he has helped show me the ropes since I was just a little kid.

RICHARD
CHILDRESS

Birthdate: September 21, 1945
Birthplace: Winston-Salem, North Carolina
Residence: Clemmons, North Carolina
Family and Personal: Married to Judy; father of Tina; grandfather of Austin and Ty; owner of Richard Childress Racing, which includes three NASCAR Sprint Cup Series teams (Nos. 29, 31, and 07) and three NASCAR Nationwide Series teams (Nos. 2, 21, and 29); proprietor of Childress Vineyards

Career Highlights

2006: Named NASCAR Owner of the Year by *The Sporting News*
2001: First NASCAR team organization to win championships in the NASCAR Sprint Cup Series (1986, 1987, 1990, 1991, 1993, 1994), NASCAR Nationwide Series (2001 and 2003), and NASCAR Craftsman Truck Series (1995)
1969 to 1981: NASCAR Sprint Cup Series driver, six Top 5 and 76 Top 10 finishes

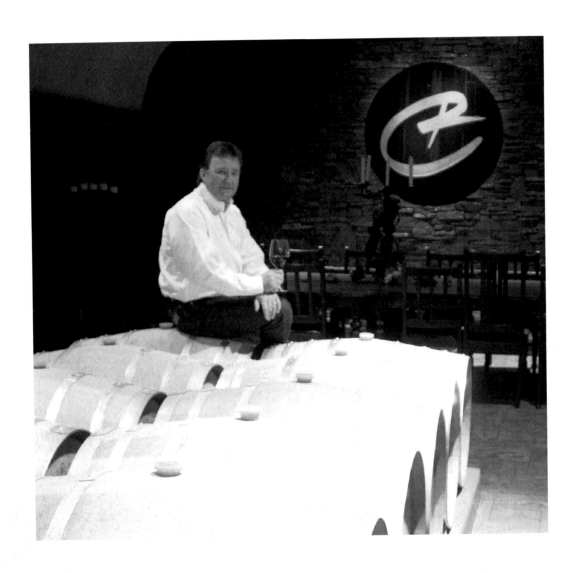

I love to take an idea and make it work. Judy and I have
a passion for hunting, and we have immensely enjoyed
creating Childress Vineyards together.

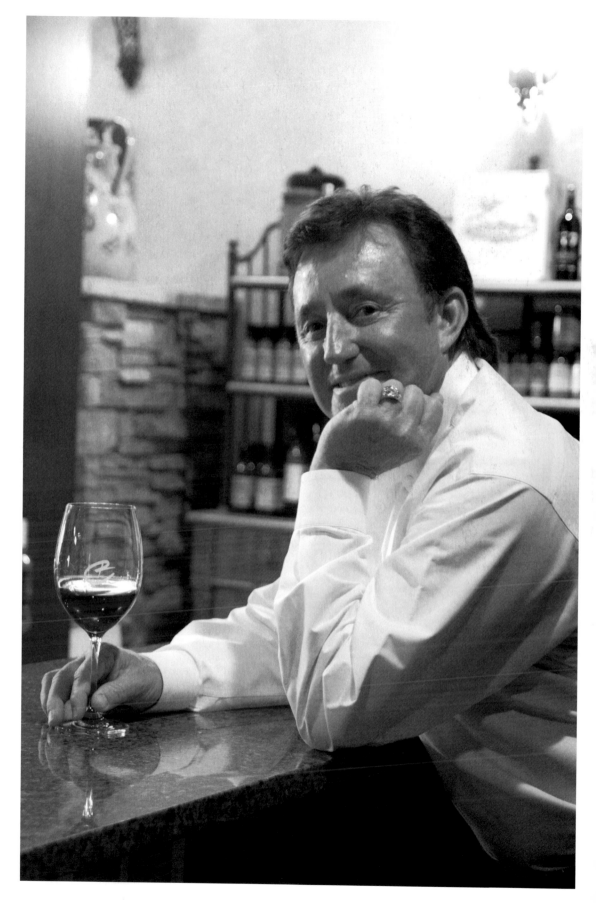

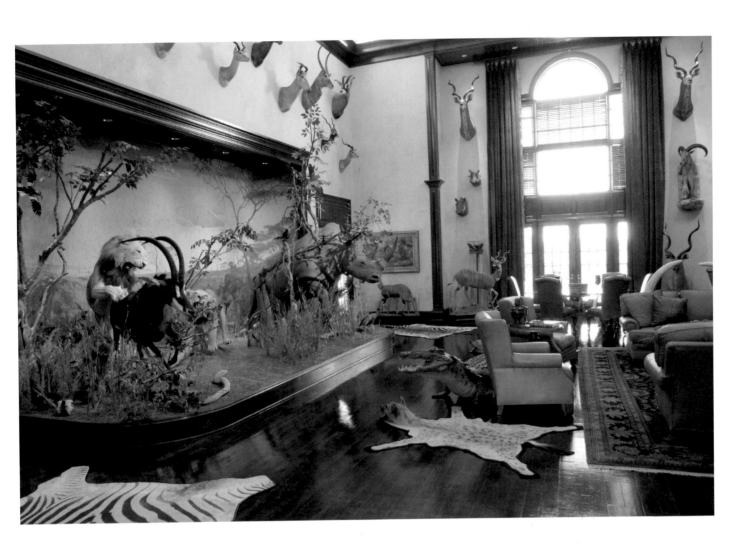

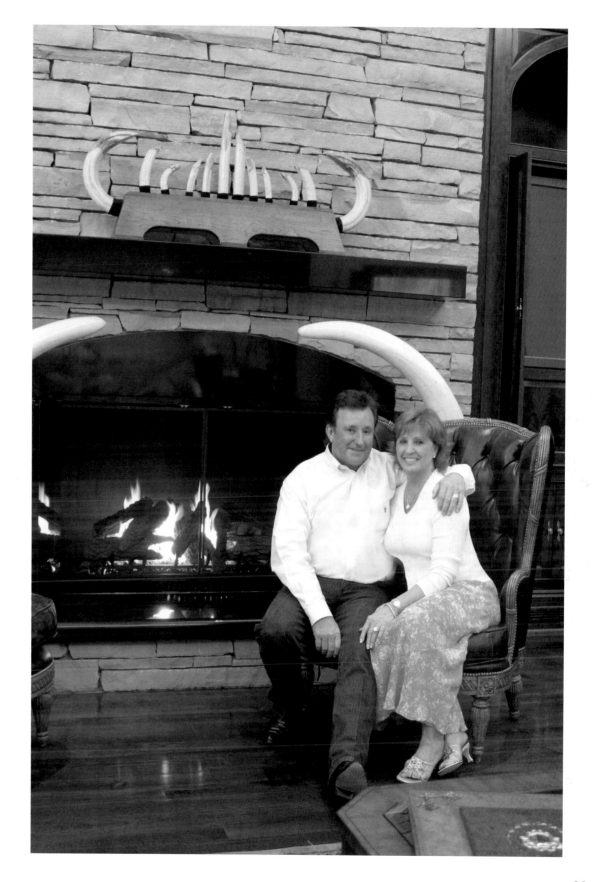

WALLY
DALLENBACH

Birthdate: May 23, 1963
Birthplace: East Brunswick, New Jersey
Residence: San Antonio, Texas
Family and Personal: Married to Robin; father of Jake, Wyatt, and Kate; son of legendary open-wheel driver and former CART chief steward Wally Dallenbach Sr.; serves as NBC and TNT race analyst; host of *Track and Trail Adventures* on the Outdoor Channel

Career Highlights

Class winner at the 24 Hours of Daytona four times (1985, 1991, 1992, 1993) and 12 Hours of Sebring three times (1985, 1988, 1989)
1985 and 1986: SCAA Trans-Am Champion
1984: SCAA Trans-Am Rookie of the Year

I would not have made it half this far without Robin. We are blessed with the family we have. I ride them hard to do things right, and they do.

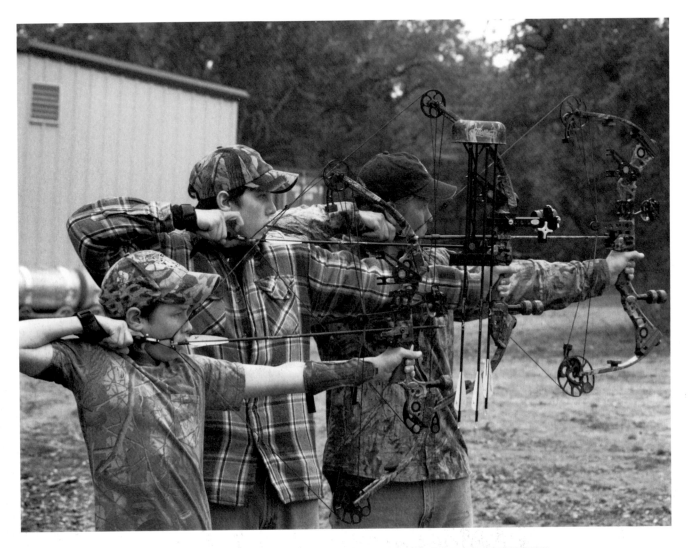

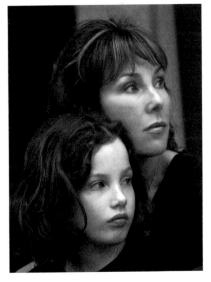

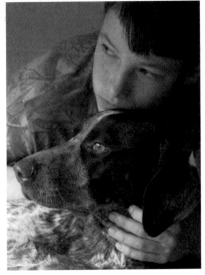

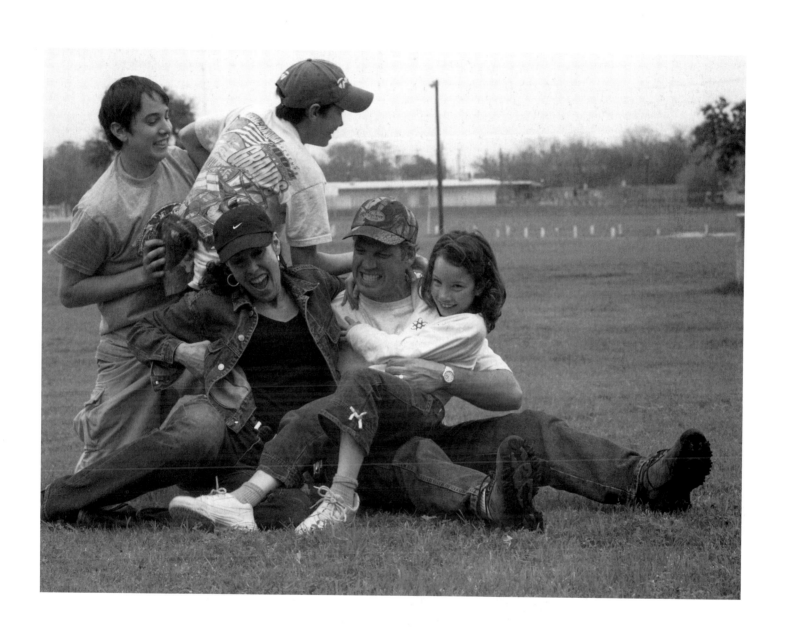

BILL
DAVIS

Birthdate: January 18, 1951
Birthplace: Fayetteville, Arkansas
Residence: Batesville, Arkansas
Family and Personal: Married to Gail; owner of Bill Davis Racing, which includes two NASCAR Sprint Cup Series teams (Nos. 22 and 36) and five NASCAR Craftsman Truck Series teams (Nos. 5, 22, 23, 27, and 02); owner, Bill Davis Trucking

Career Highlights

2005: With Mike Skinner's NASCAR Craftsman Truck Series victory at Bristol, claims wins in all three premier NASCAR series
2002: Won Daytona 500 with Ward Burton
1991: Driver Jeff Gordon wins NASCAR Nationwide Series Raybestos Rookie of the Year

The ranch is where we feel at home. The enormity of its beauty humbles us. I'm always in touch with what is going on, but this is my favorite place to be.

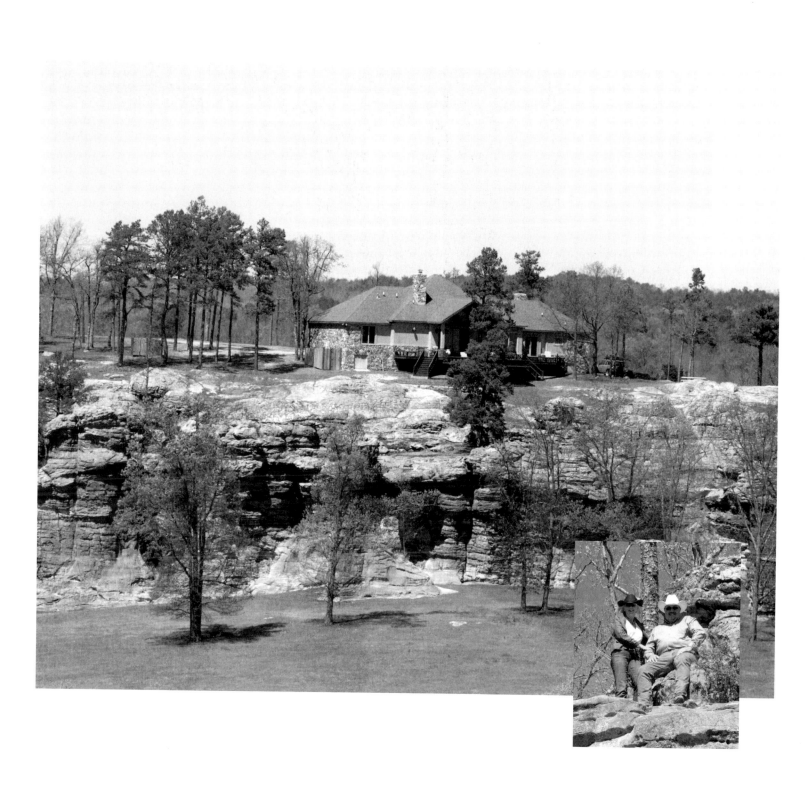

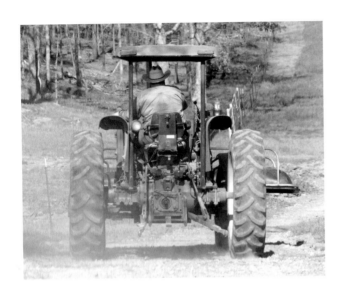

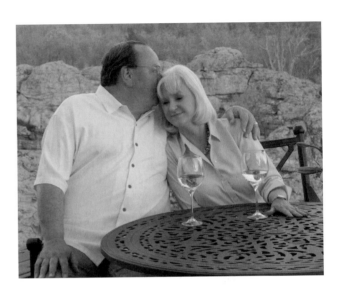

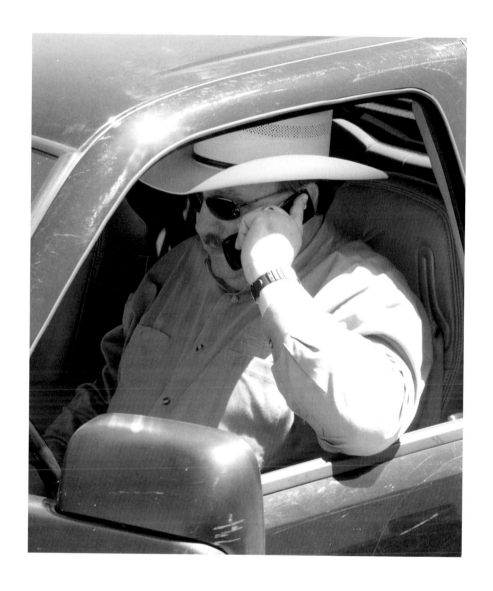

DALE
EARNHARDT JR.

Birthdate: October 10, 1974
Birthplace: Concord, North Carolina
Residence: Mooresville, North Carolina
Family and Personal: Single; son of racing legend Dale Earnhardt; grandson of racing pioneer Ralph Earnhardt; and grandson of renowned NASCAR fabricator and mechanic Robert Gee; owner, No. 88 NASCAR Nationwide Series team, No. 88S Hooters Pro Cup team, and two R&B late model teams (Nos. 71 and 73)

Career Highlights

2003-2006: Voted NASCAR Most Popular Driver each year
2004: Won Daytona 500
1998, 1999: Won NASCAR Nationwide Series championship, becoming first third-generational NASCAR champion

Whiskey River is my place to get away from it all, to reflect and refocus.

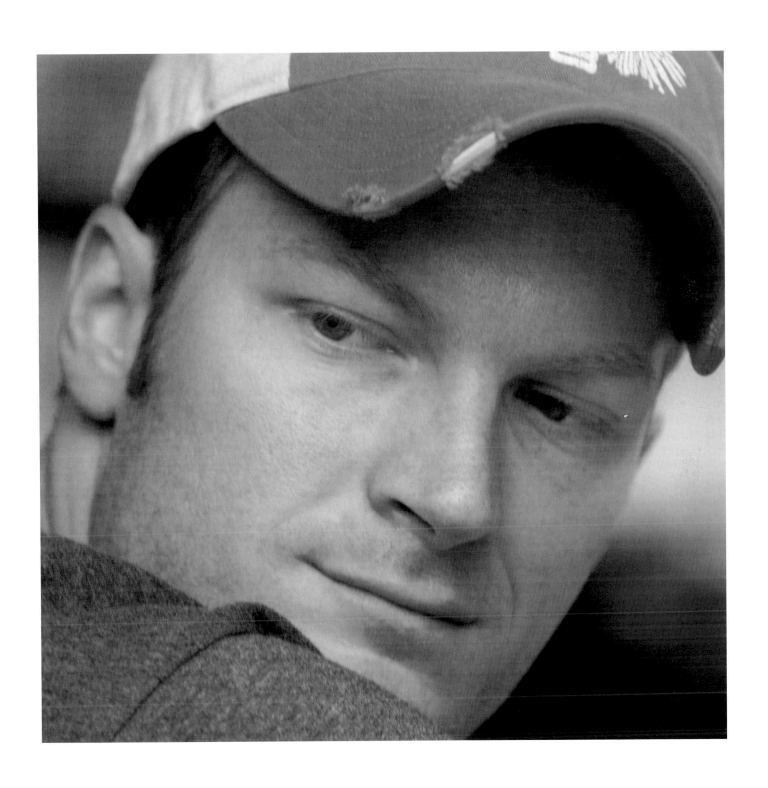

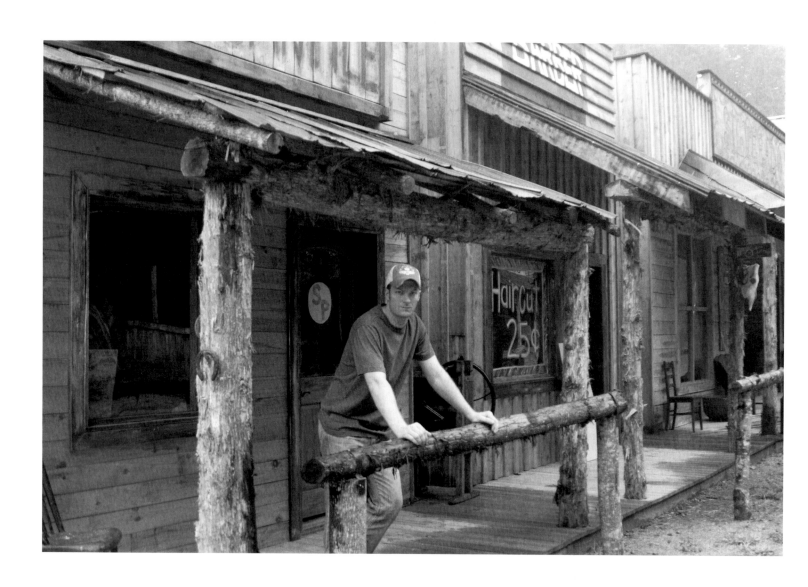

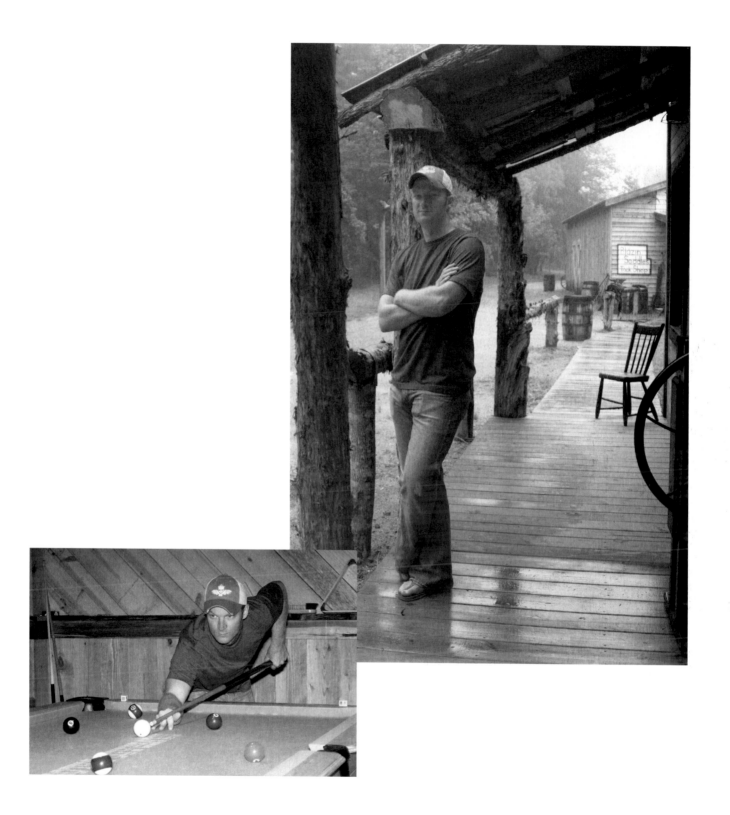

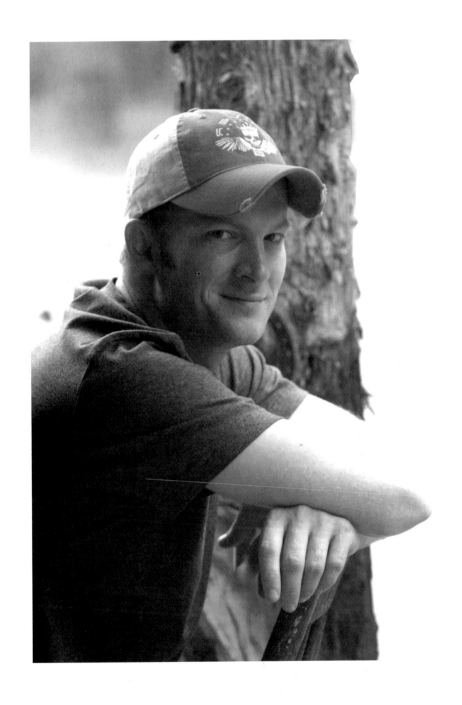

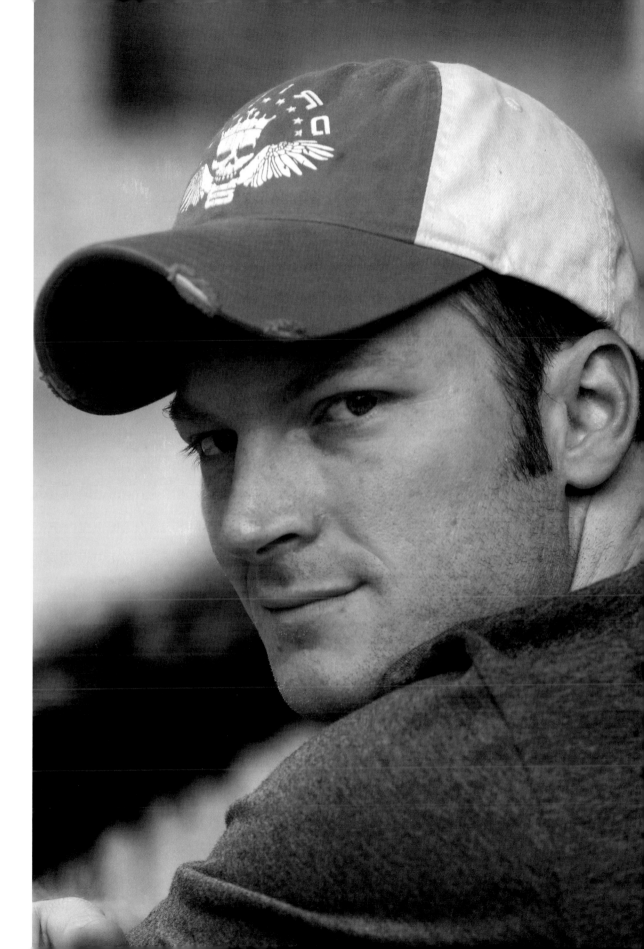

RAY
EVERNHAM

Birthdate: August 26, 1957
Birthplace: Hazlet, New Jersey
Residence: Cornelius, North Carolina
Family and Personal: Son, Ray J.; owner of Evernham Motorsports, which includes three NASCAR Sprint Cup Series teams (Nos. 9, 10, and 19), No. 98 ARCA team, and No. 9 NASCAR Nationwide Series team

Career Highlights

2006: Voted Greatest Crew Chief of All Time by a media vote
2000: Named Crew Chief of the Decade for work with Hendrick Motorsports, including three championships (1995, 1997, 1998) with Jeff Gordon
1999: Founded Evernham Motorsports
1999: *NASCAR Winston Cup Illustrated* Person of the Year

51

Chrome, man, lots of chrome and loud pipes. I
love this Harley! Beach Boys music, fuzzy dice,
and a yellow ragtop. My best buddy Ray J. is just
one year away from the driver's seat.

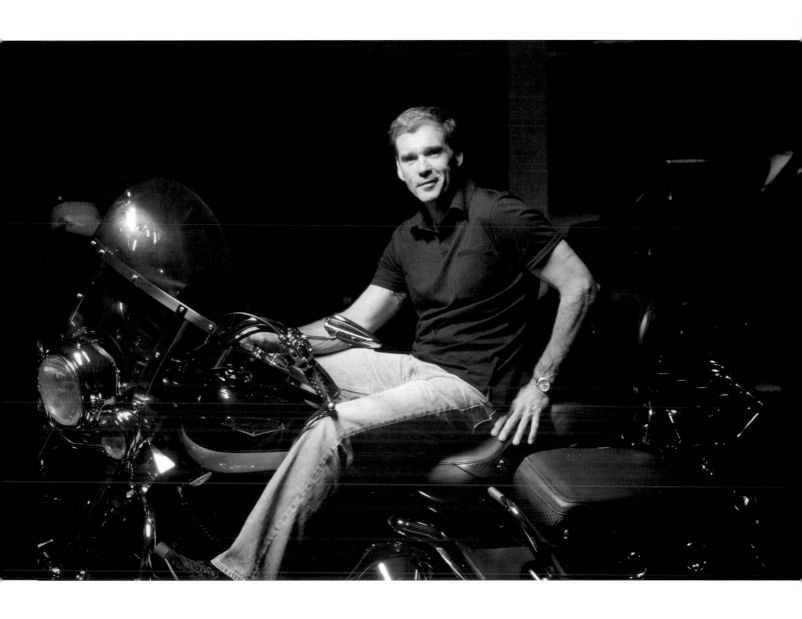

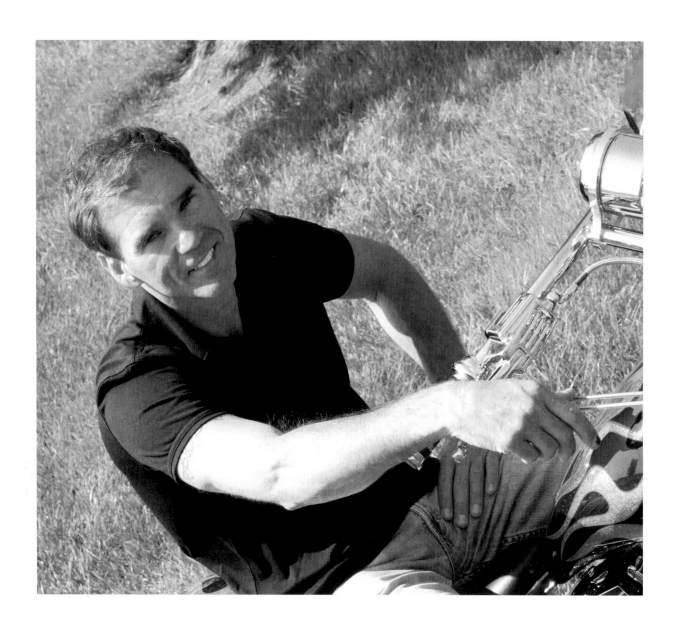

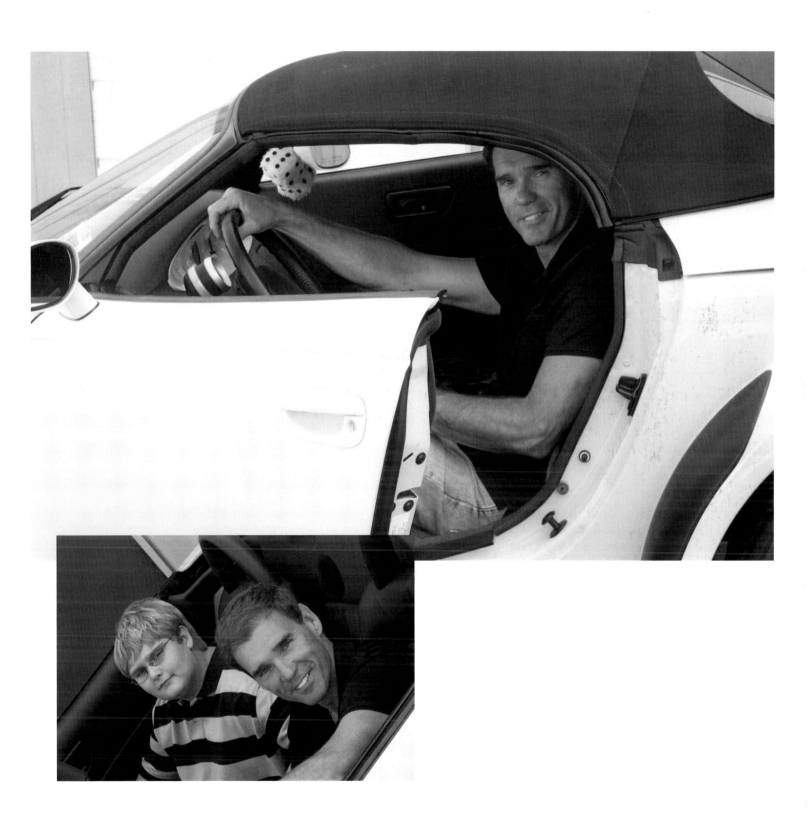

BILL
FRANCE

Birthdate: April 4, 1933–June 4, 2007
Birthplace: Washington, D.C.
Family and Personal: Husband of Betty Jane; father of Brian and Lesa; son of NASCAR founder Bill France Sr.; owner, International Speedway Corp.

Career Highlights

2006: Inducted into Automotive Hall of Fame
2004: Inducted into Motorsports Hall of Fame of America
2004: Inducted into International Motorsports Hall of Fame
2004: Inducted into Motorcycle Hall of Fame
1972: Named Chairman and CEO of NASCAR

This is a grand moment in time. We have shared
precious moments as well as solitude here.

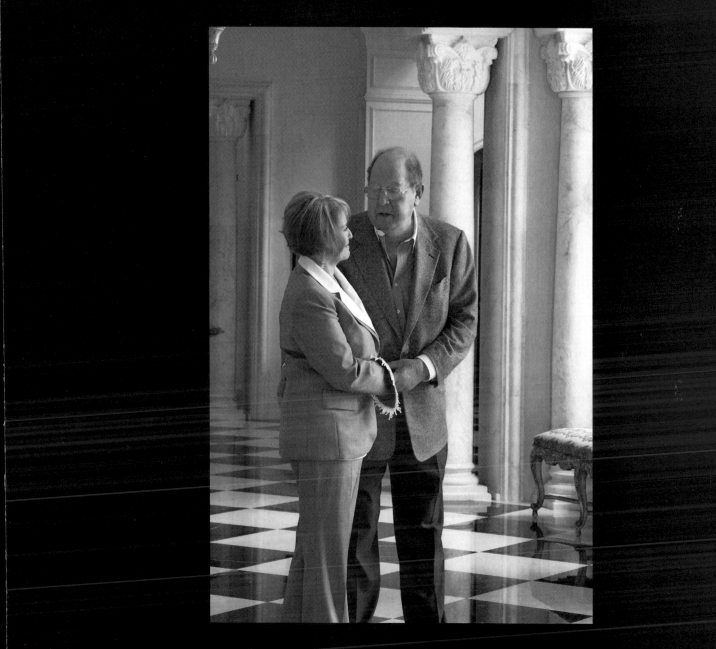

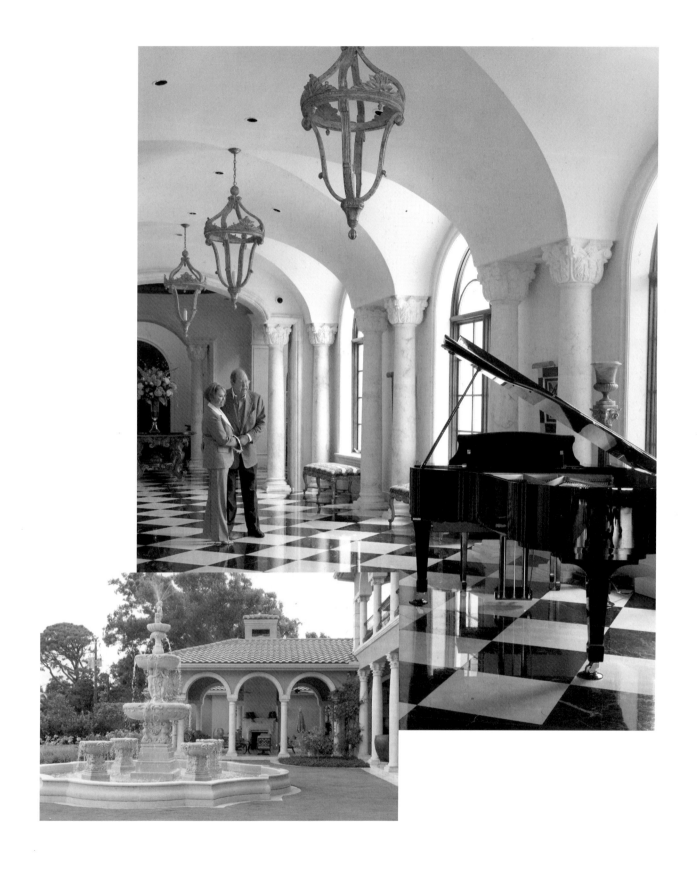

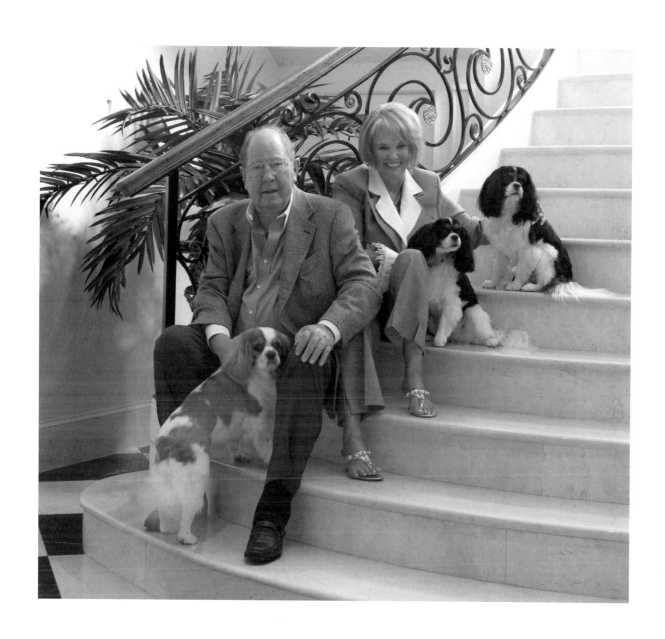

ROBBY
GORDON

Birthdate: January 2, 1969
Birthplace: Orange, California
Residence: Cornelius, North Carolina, and Anaheim, California
Family and Personal: Single; owner, Robbie Gordon Motorsports, which includes No. 7 NASCAR Sprint Cup Series team and No. 55 NASCAR Nationwide Series team

Career Highlights

2006: Won third career Baja 1000 (also won in 1987 and 1989)
2001: Won first NASCAR Sprint Cup Series race, New Hampshire 300
1991 to 1994: Class winner at the 24 Hours of Daytona four consecutive times

It all starts here!

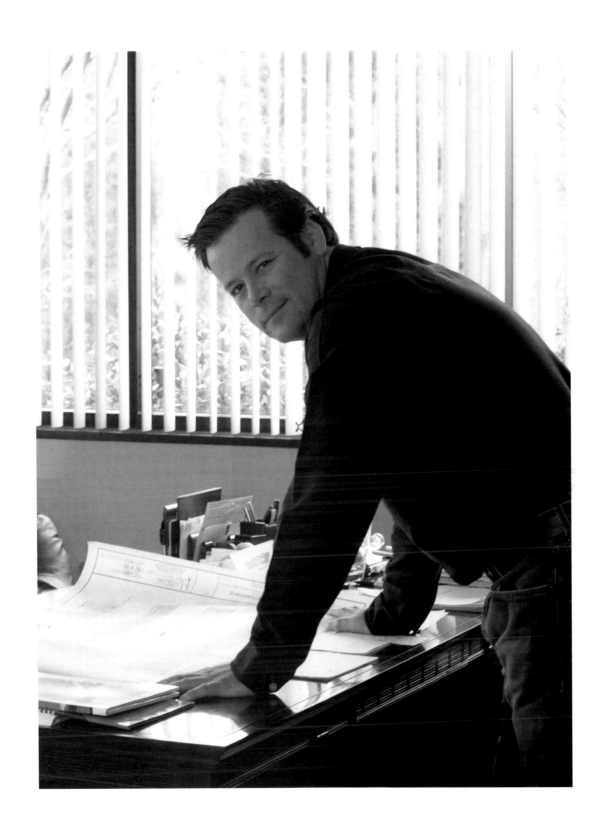

JEFF
GREEN

Birthdate: September 6, 1962
Birthplace: Owensboro, Kentucky
Residence: Davidson, North Carolina
Family and Personal: Married to Michelle; godfather of Brock and Brody Biggs; brother of NASCAR drivers Mark and David

Career Highlights

2001: Won first NASCAR Sprint Cup Series Coors Light Pole Award, Sharpie 400 at Bristol
2000: Won NASCAR Nationwide Series championship with record 25 Top 5 finishes
1990: Won track championship at Nashville Speedway USA

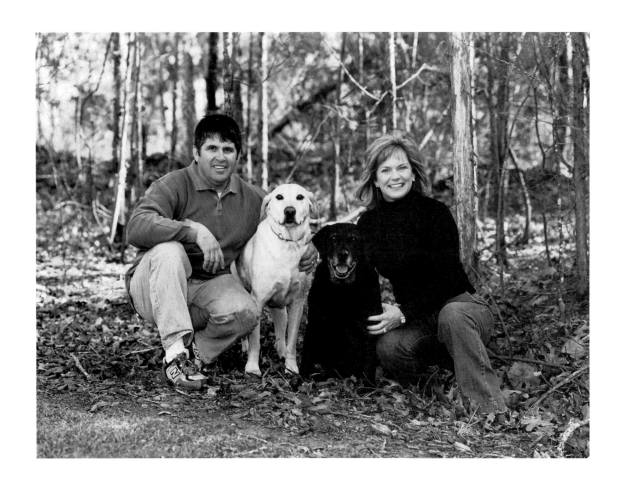

Michelle and I have known each other since high
school. Outside of our home, my workshop is my
sanctuary. We feel so lucky to share in the lives of our
two precious godsons.

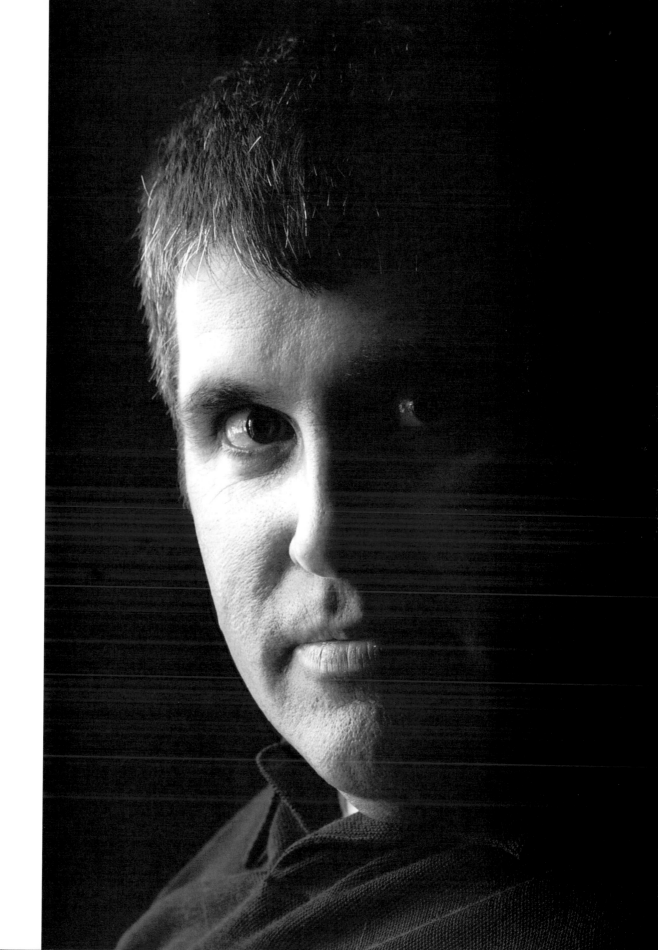

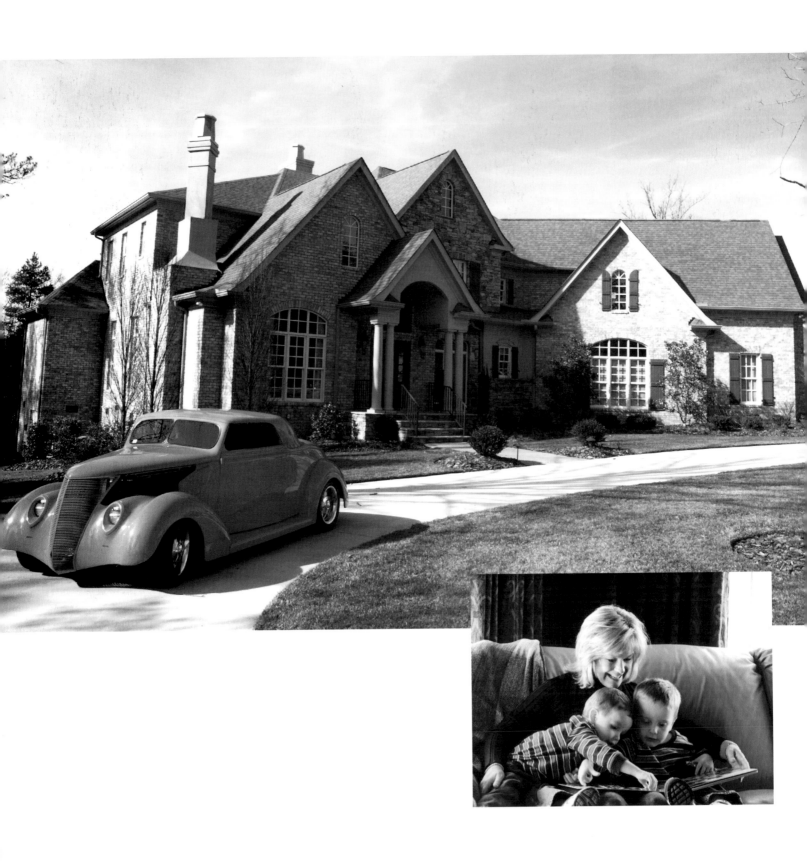

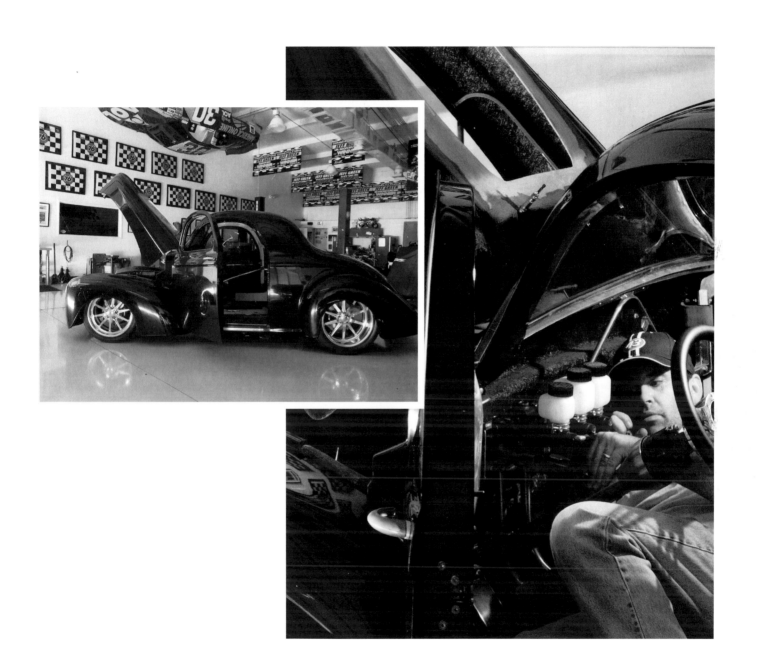

KEVIN HARVICK

Birthdate: December 8, 1975
Birthplace: Bakersfield, California
Residence: Kernersville, North Carolina
Family and Personal: Married to DeLana; owner, Kevin Harvick Inc., which includes two NASCAR Nationwide Series teams (Nos. 33 and 77) and two NASCAR Craftsman Truck Series teams (Nos. 2 and 33)

Career Highlights

2006: NASCAR Nationwide Series Champion
2001: NASCAR Sprint Cup Series Raybestos Rookie of the Year
2001: NASCAR Nationwide Series Champion
2000: NASCAR Nationwide Series Raybestos Rookie of the Year
1998: NASCAR Grand National Division, West Series Champion
1995: NASCAR Southwest Series Rookie of the Year

We love to be outdoors on our property. We built a special bridge that overlooks the stream, and we often take long walks there in the evening. We cherish DeLana's dad's old tractor, because it reminds us of him.

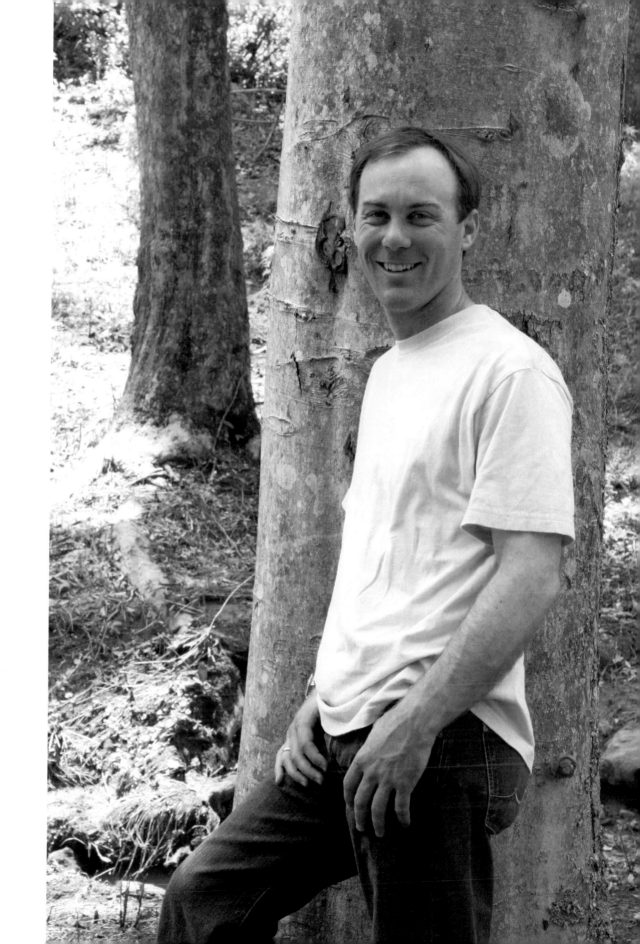

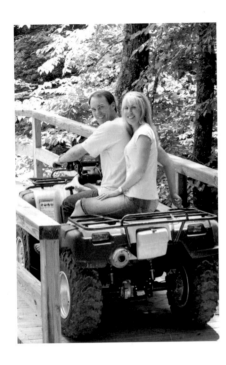 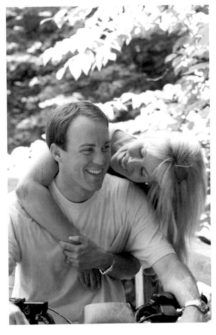 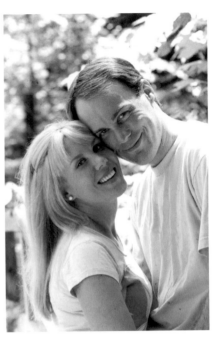

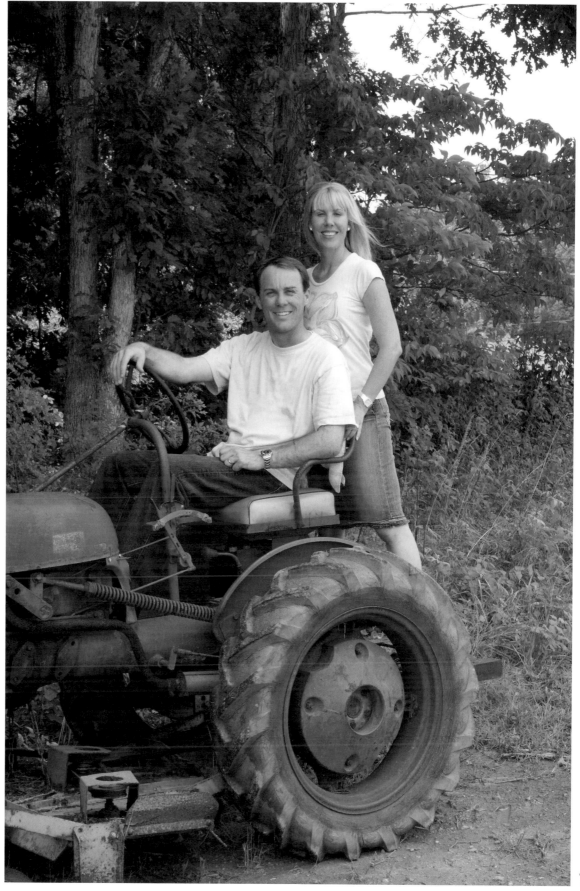

MIKE
HELTON

Birthdate: August 30, 1953
Birthplace: Bristol, Tennessee
Residence: Ormond Beach, Florida
Family and Personal: Married to Lynda; father of Rich and Tina; grandfather of Luke and Maci Lyn

Career Highlights

2000: Succeeded Bill France as President of NASCAR
1994: Vice President for Competition, NASCAR
1989: President of Talladega Speedway
1986: Joined management team of Daytona International Speedway
1985: General Manager of Atlanta International Raceway

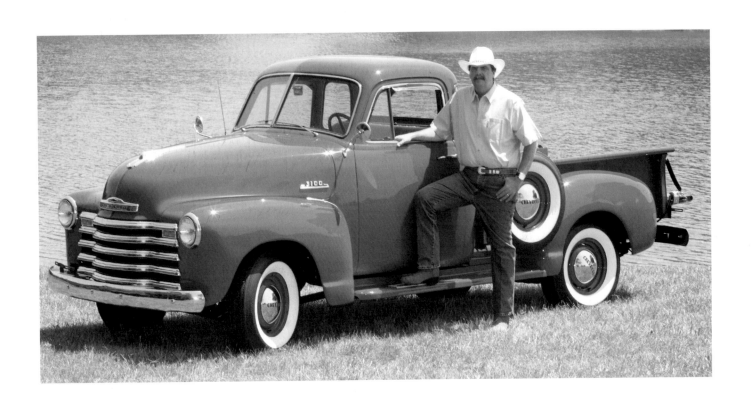

I enjoy the energy that my life gives to me. This home was
built for family, and we are so proud of them! Our
grandkids have changed our lives so much.

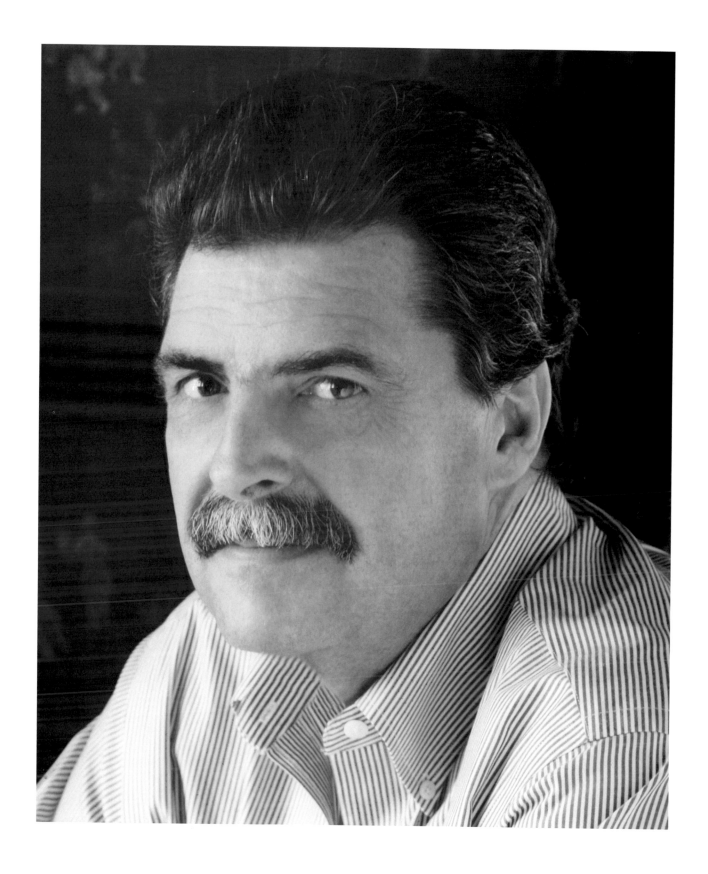

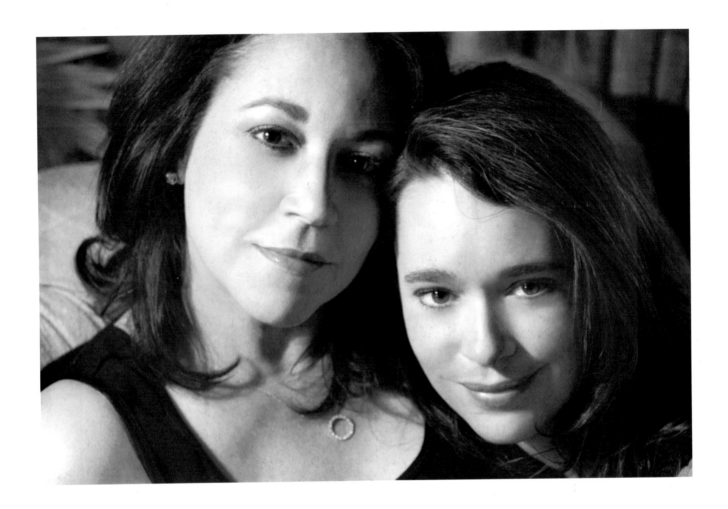

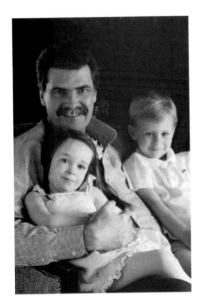

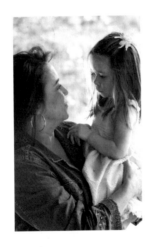

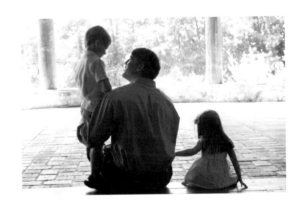

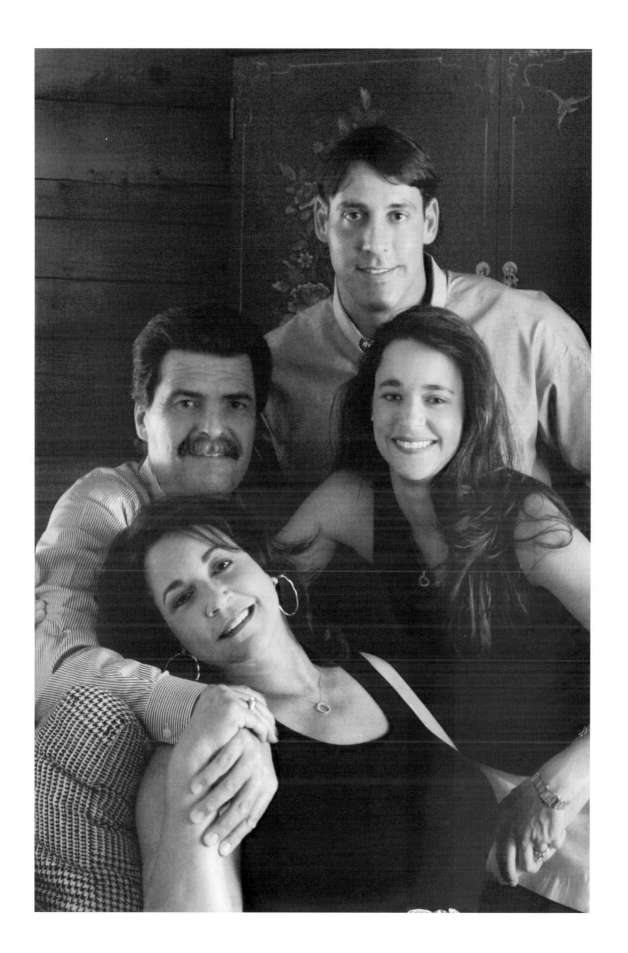

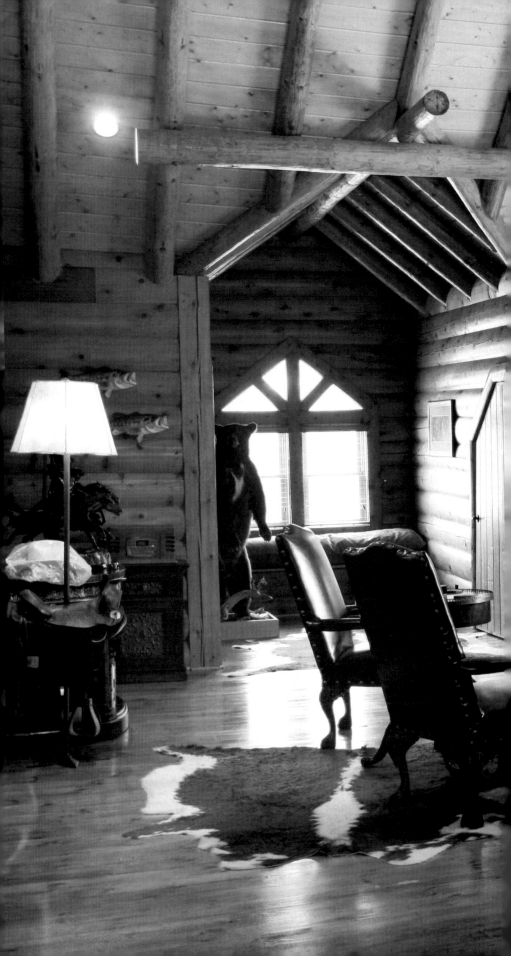

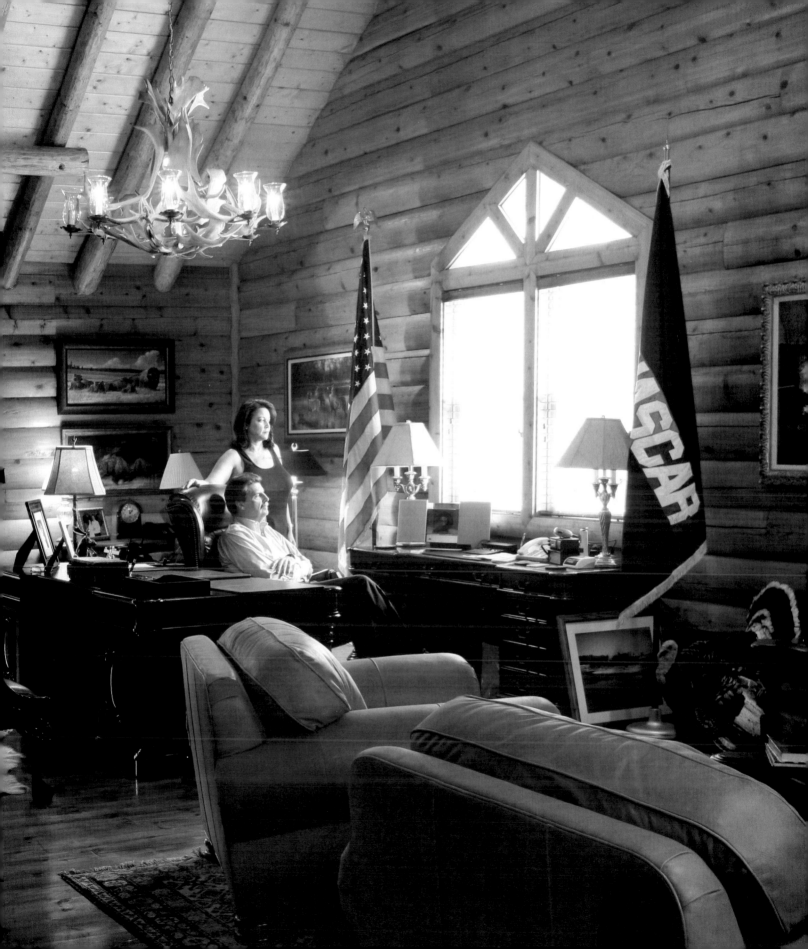

JIMMIE
JOHNSON

Birthdate: September 17, 1975
Birthplace: El Cajon, California
Residence: Charlotte, North Carolina
Family and Personal: Married to Chandra

Career Highlights

2007: NASCAR Sprint Cup Series champion
2006: NASCAR Sprint Cup Series champion
2002: NASCAR Sprint Cup Series Raybestos Rookie of the
 Year runner-up
1998: ASA Rookie of the Year
1996-1997: SODA Winter Series Champion
1993: SCORE Class 10 Desert Series Champion

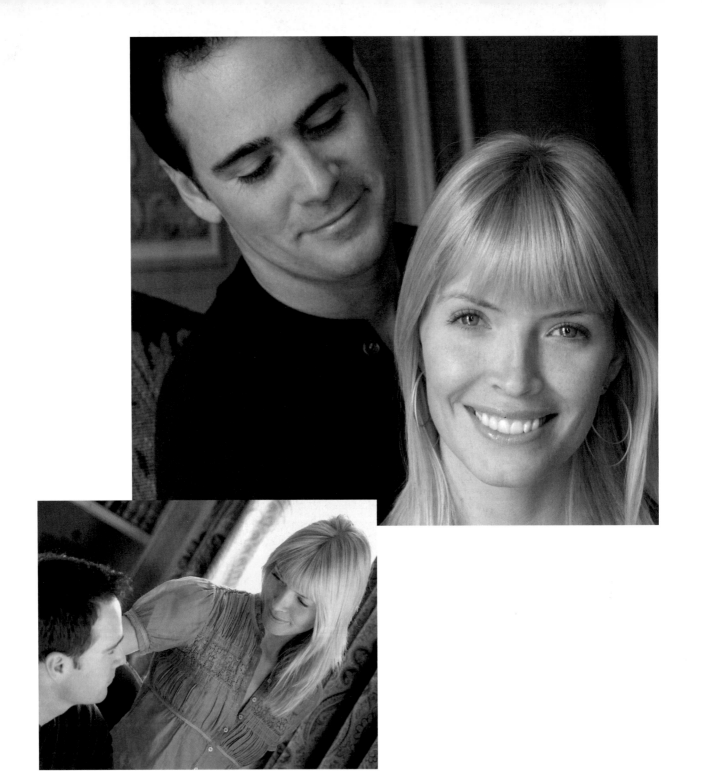

I couldn't ask for anything more. It is so exciting to be building our future together.

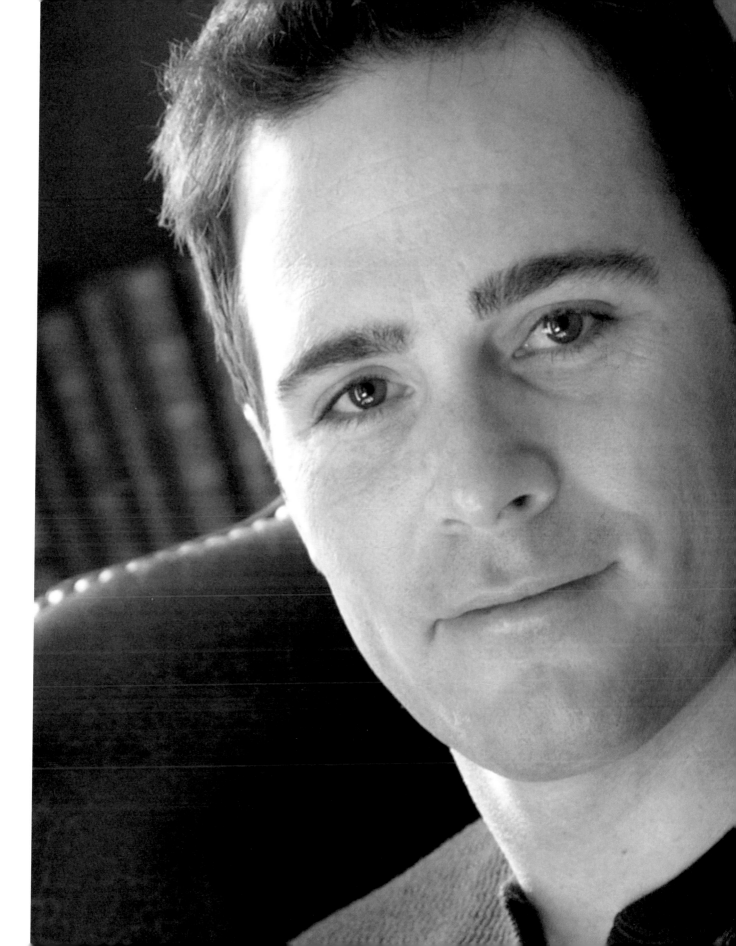

BOBBY
LABONTE

Birthdate: May 8, 1964
Birthplace: Corpus Christi, Texas
Residence: Trinity, North Carolina
Family and Personal: Married to Donna; father of Robert and Madison; brother of 1984 NASCAR Sprint Cup Series Champion Terry Labonte

Career Highlights

2001: IROC Champion
2000: NASCAR Sprint Cup Series Champion
1991: NASCAR Nationwide Series Champion

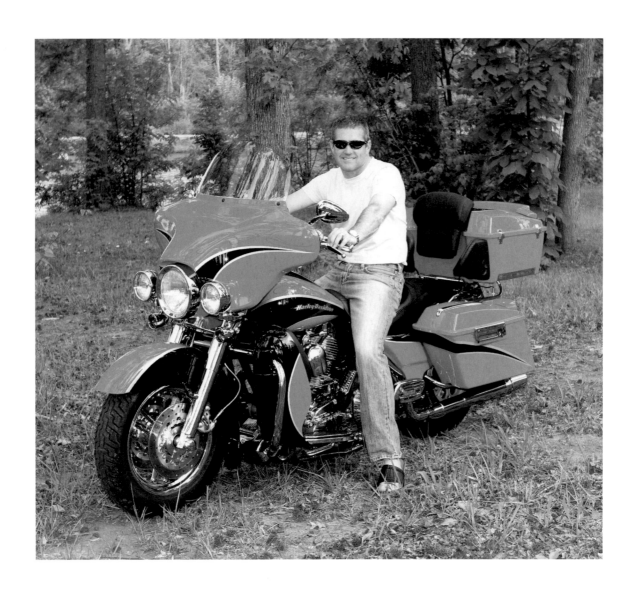

Donna and I are so close, and our family spends a lot of time
together. We like each other a lot!

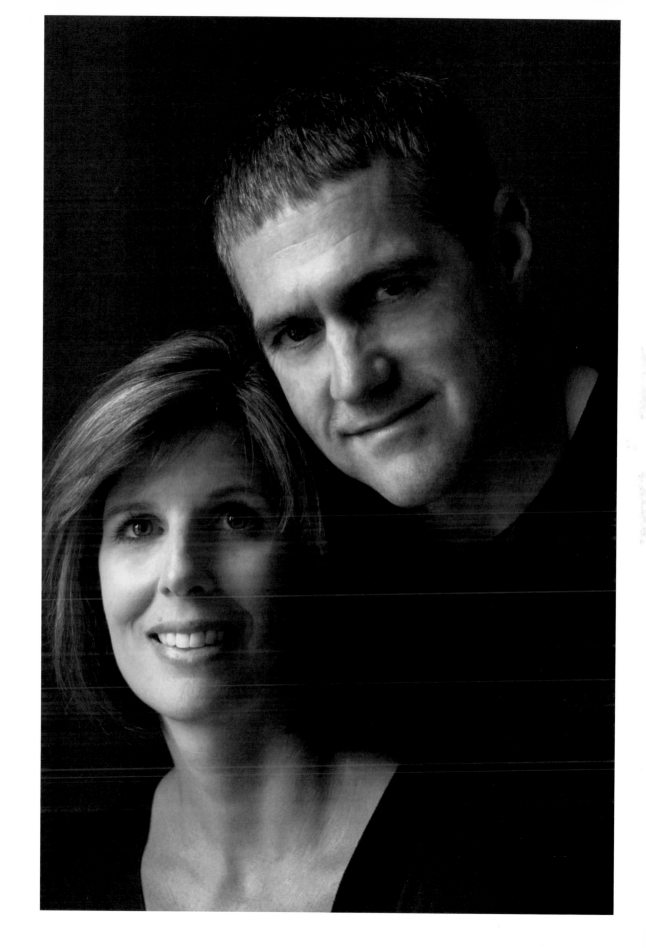

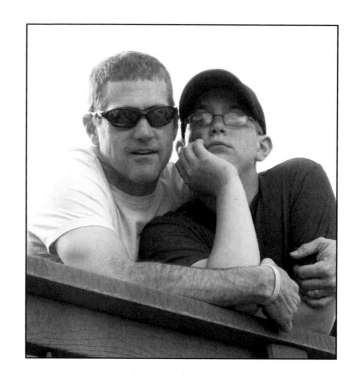

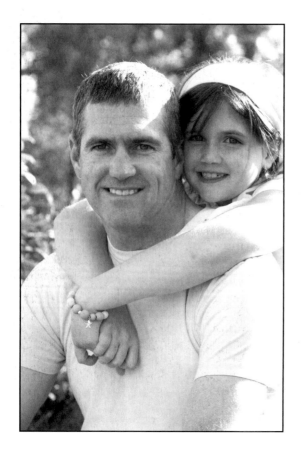

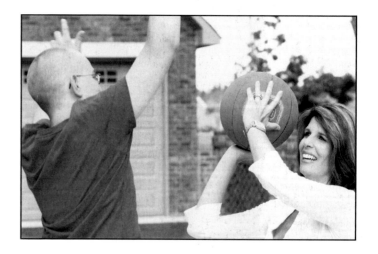

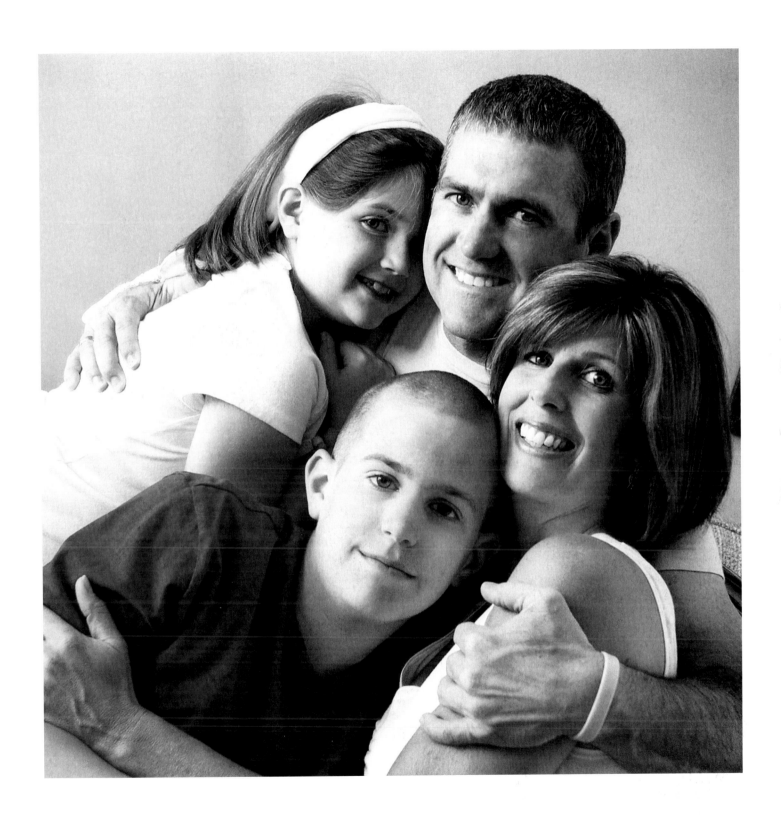

MARK
MARTIN

Birthdate: January 9, 1959
Birthplace: Batesville, Arkansas
Residence: Daytona Beach, Florida
Family and Personal: Married to Arlene; father of Amy, Heather, Rachel, Stacy, and Matthew; owner of Mark Martin Ford-Mercury dealership and museum in Batesville, Arkansas

Career Highlights

2005: Won 5th IROC Championship (1994, 1996, 1997, 1998)
1998: Named one of NASCAR's 50 Greatest Drivers of All Time
1989: First NASCAR Sprint Cup Series victory, AC Delco 500 at Rockingham
1987: ASA Rookie of the Year

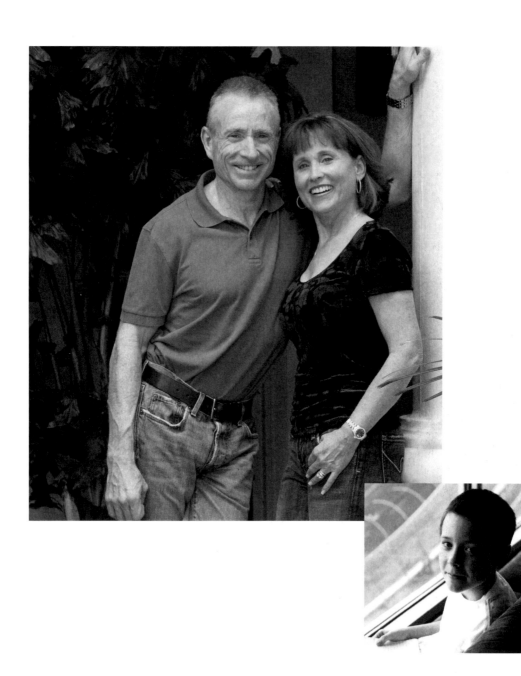

Arlene is my inspiration. It is so important to live your dreams.
One of ours was opening our dealership and museum in
Arkansas.

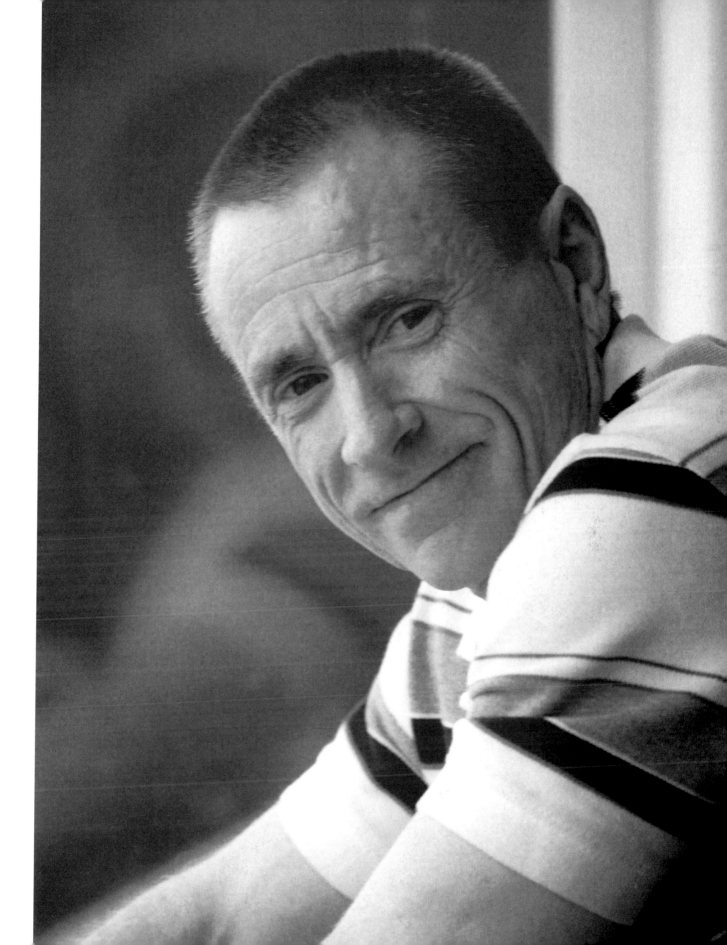

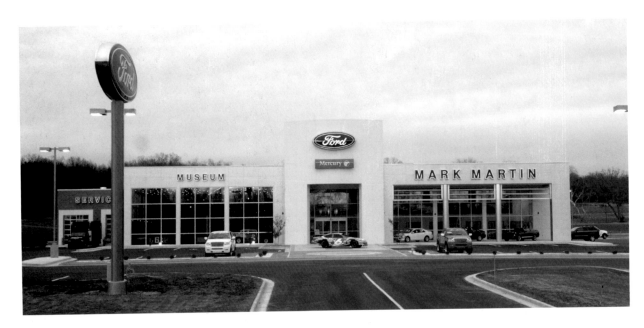

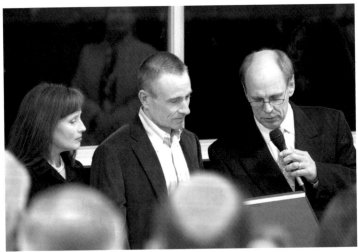

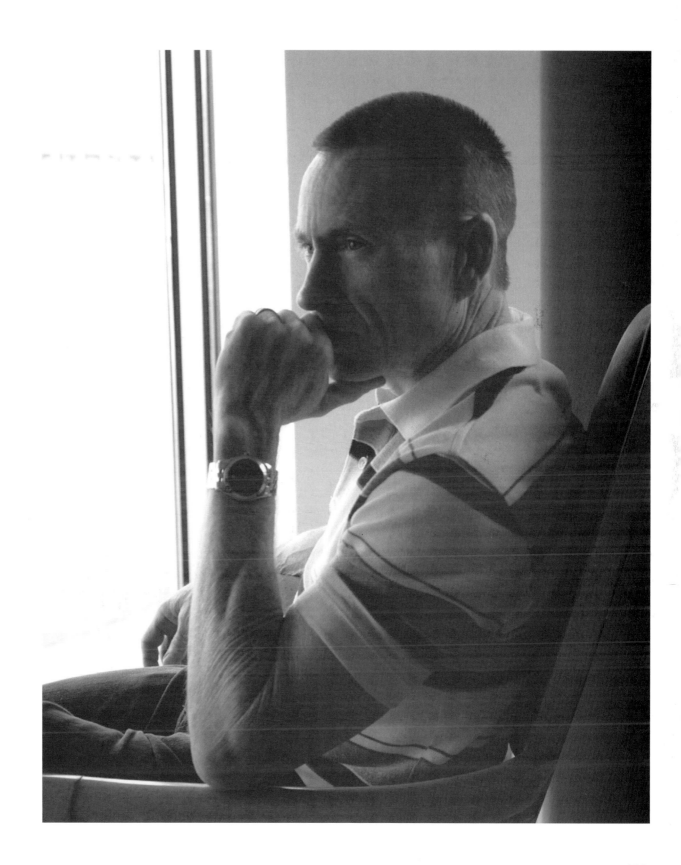

CASEY
MEARS

Birthdate: March 12, 1978
Birthplace: Bakersfield, California
Residence: Huntersville, North Carolina
Family and Personal: Single; son of Carol and off-road racing legend Roger Mears; nephew of four-time Indianapolis 500 winner Rick Mears

Career Highlights

2007: First NASCAR Sprint Cup Series victory, 2007 Coca-Cola 600 at Charlotte
2006: Co-winner, 24 Hours of Daytona
2004: Became first driver in 40 years to win first two career NASCAR Sprint Cup Series Coors Light Pole Awards in consecutive races (at Pocono and Indianapolis)

I love being with my parents, my Harley, staying fit,
and being on the water!

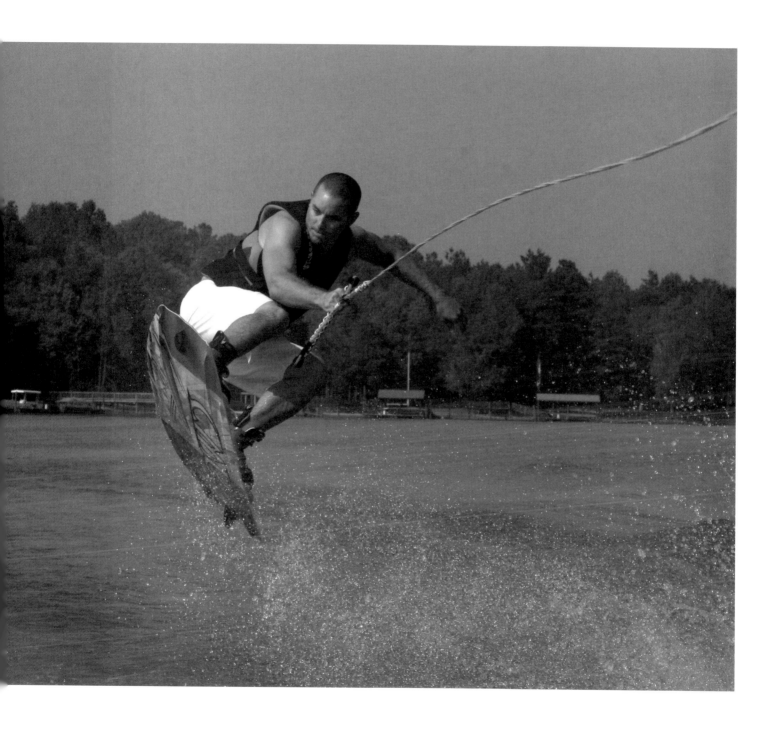

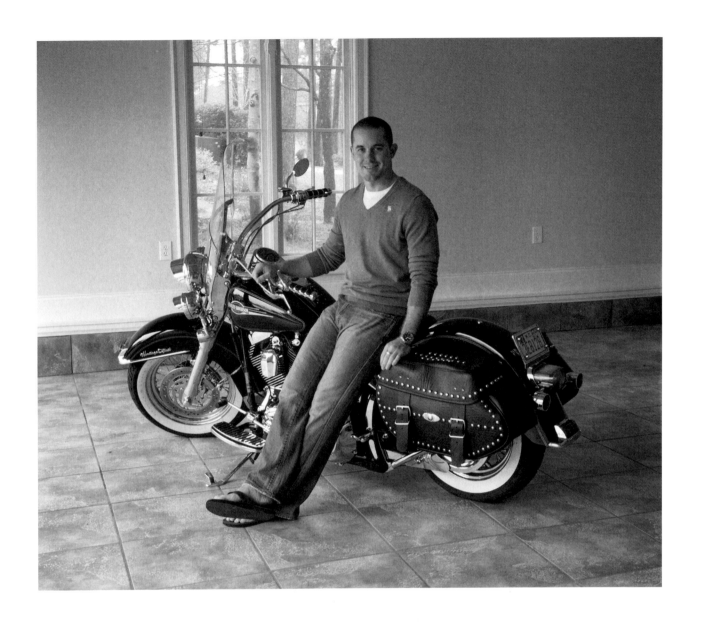

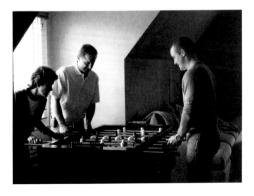

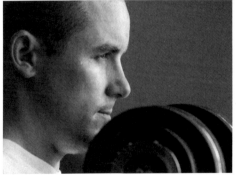

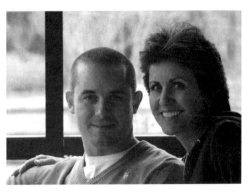

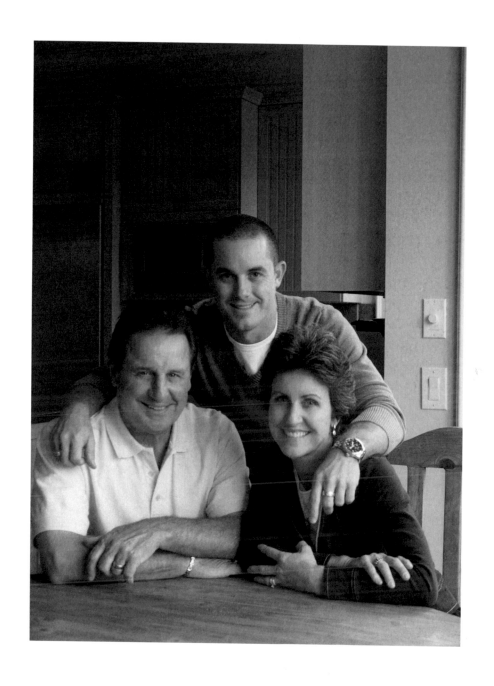

JOE NEMECHEK

Birthdate: September 26, 1963
Birthplace: Lakeland, Florida
Residence: Mooresville, North Carolina
Family and Personal: Married to Andrea; father of John Hunter, Blair, and Kennedy

Career Highlights

1999: First NASCAR Sprint Cup Series victory, Dura Lube/ K-Mart 300 at New Hampshire
1992: NASCAR Nationwide Series Champion
1990: NASCAR Nationwide Series Raybestos Rookie of the Year
1989: All-Pro Late Model Series Champion and Rookie of the Year

Our lives are happy and full, and our kids fill us with pride. We appreciate everything that life brings us.

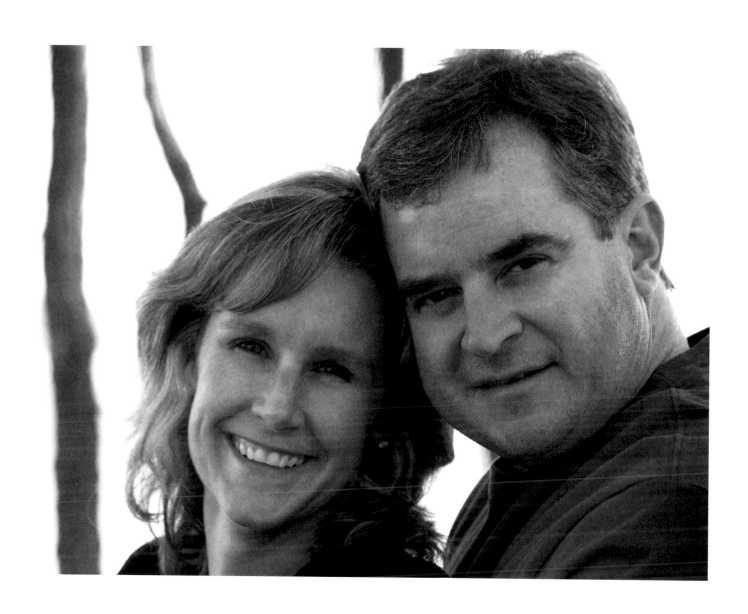

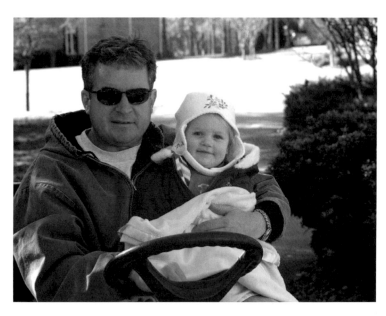
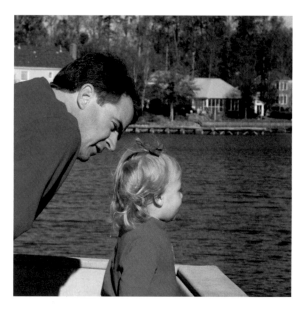
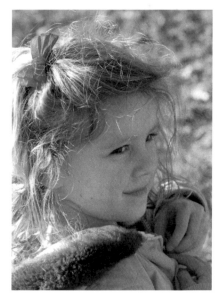
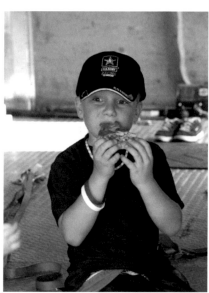

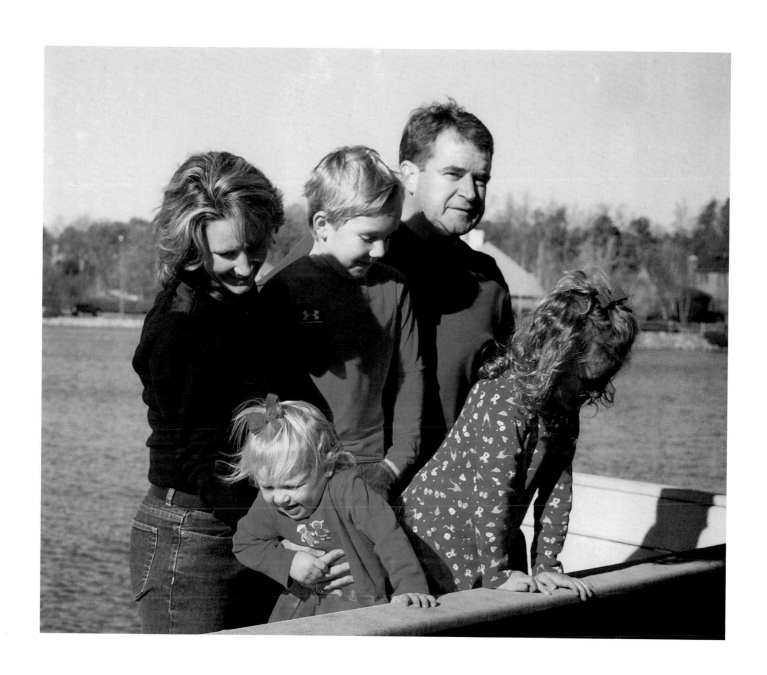

BENNY
PARSONS

Birthdate: July 12, 1941 – January 16, 2007
Birthplace: North Wilkesboro, North Carolina
Family and Personal: Husband of Terri; father of Kevin and Keith; grandfather of Emily and Libbie

Career Highlights

2006: Inducted into Motorsports Hall of Fame of America
1998: Named one of NASCAR's 50 Greatest Drivers of All Time
1994: Inducted into International Motorsports Hall of Fame
1982: First driver to qualify a stock car faster than 200 mph, Winston 500 at Talladega
1973: NASCAR Sprint Cup Series Champion
1968 and 1969: ARCA Champion
1965: ARCA Rookie of the Year

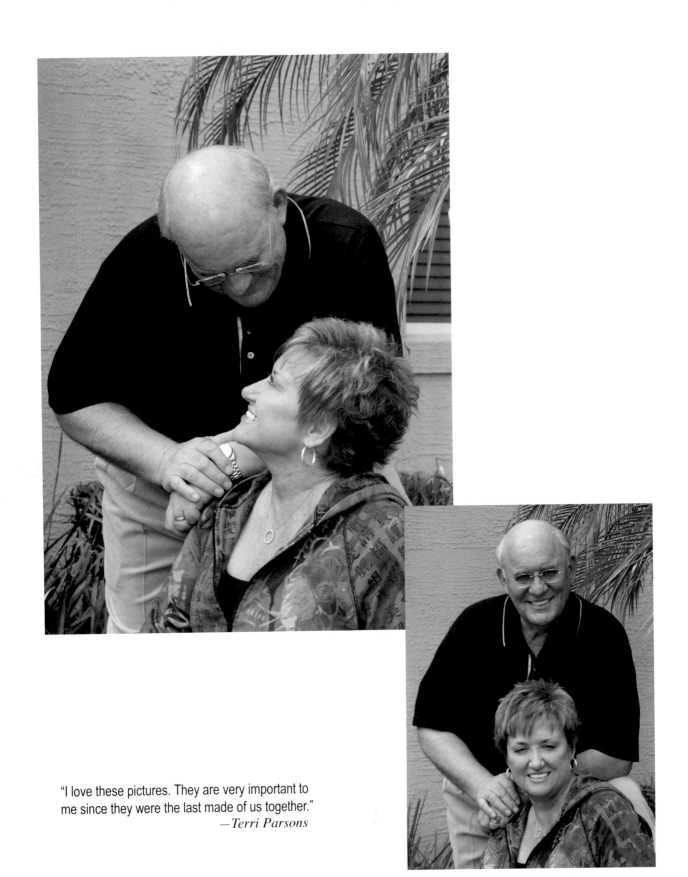

"I love these pictures. They are very important to me since they were the last made of us together."
—*Terri Parsons*

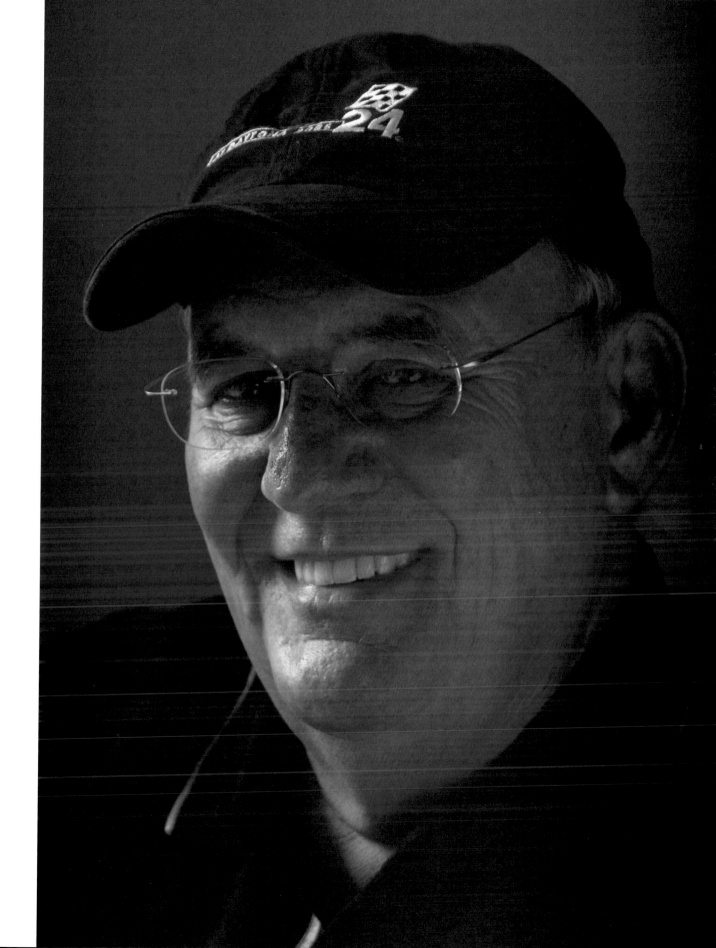

KYLE
PETTY

Birthdate: June 2, 1960
Birthplace: Randleman, North Carolina
Residence: Trinity, North Carolina
Family and Personal: Married to Pattie; father of Adam (July 10, 1980–May 12, 2000), Austin, and Montgomery Lee; son of Lynda and racing legend Richard Petty; grandson of racing pioneer Lee Petty; founder of Victory Junction Gang Camp with wife Pattie, honoring their son Adam

Career Highlights

1999: *NASCAR Winston Cup Illustrated*'s Person of the Year
1988: True Value Man of the Year
1986: First NASCAR Sprint Cup Series victory, Miller High Life 400 at Richmond

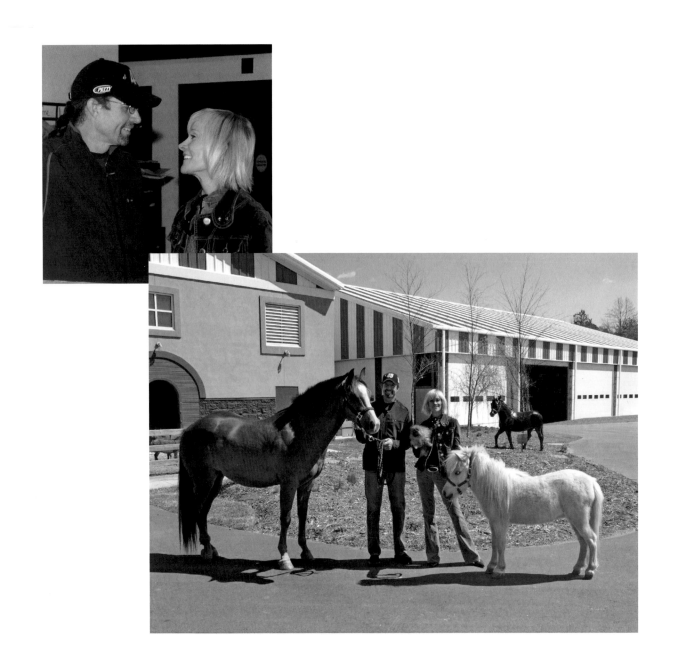

Even though our days are full, Pattie and I always find time to spend together. Relaxing for me is a game of golf!

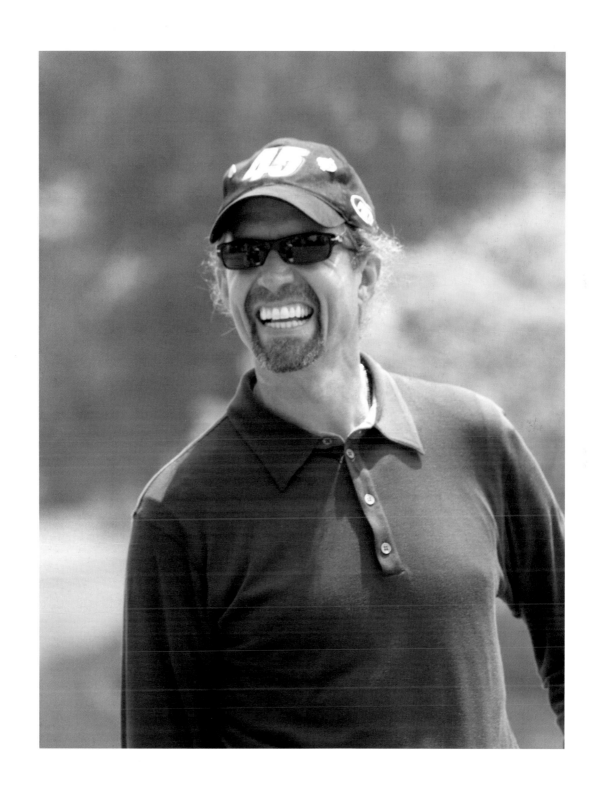

SCOTT
RIGGS

Birthdate: January 1, 1971
Birthplace: Bahama, North Carolina
Residence: Bahama, North Carolina
Family and Personal: Married to Jai; father of Layne and Skyler

Career Highlights

2005: Won first NASCAR Sprint Cup Series Coors Light Pole Award, Advance Auto Parts 500 at Martinsville
2003: NASCAR Nationwide Series Most Popular Driver
2002: NASCAR Nationwide Series Raybestos Rookie of the Year

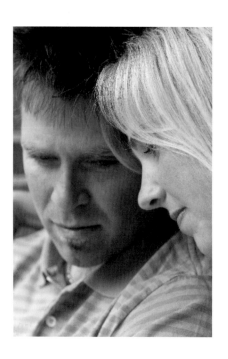

Being outside and enjoying nature is an important part of our day. We couldn't imagine this journey without each other. Family is life's greatest blessing.

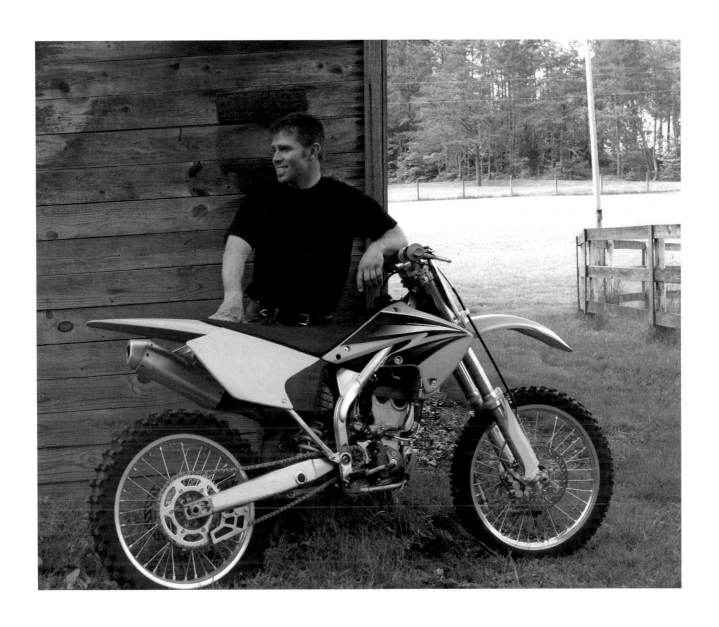

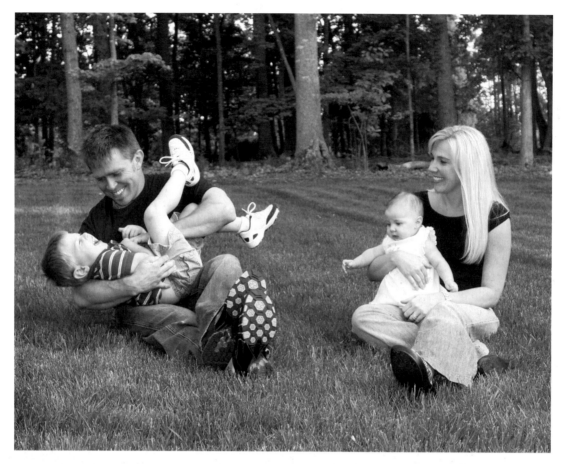

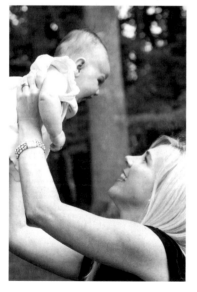
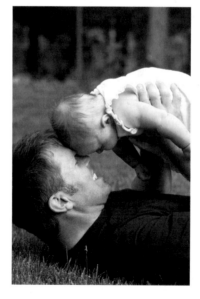
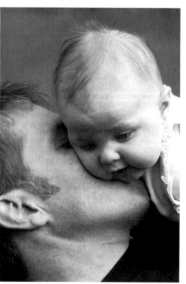

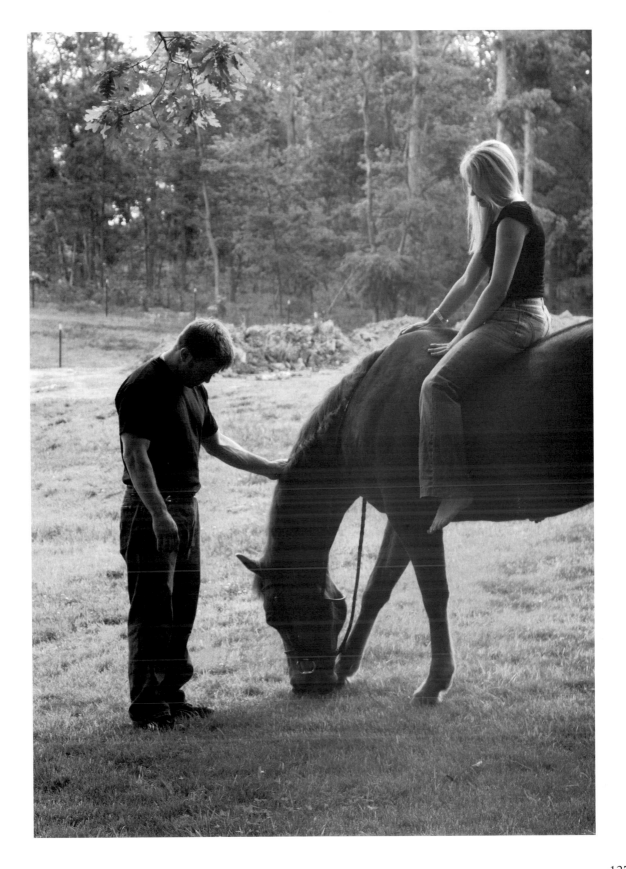

JACK
ROUSH

Birthdate: April 19, 1942
Birthplace: Covington, Kentucky, raised in Manchester, Ohio
Residence: Northville, Michigan
Family and Personal: Father of Susan, Patricia, and Jack Jr.; chairman of the board, Roush Enterprises, which includes Roush Fenway Racing and five NASCAR Sprint Cup Series teams (Nos. 6, 16, 17, 26, and 99), four NASCAR Nationwide Series teams (Nos. 6, 16, 26, and 60), and three NASCAR Craftsman Truck Series teams (Nos. 6, 50, and 99)

Career Highlights

2006: Inducted into International Motorsports Hall of Fame
2004: Won NASCAR Sprint Cup Series Championship with Kurt Busch
2003: Won NASCAR Sprint Cup Series Championship with Matt Kenseth
2002: Won NASCAR Nationwide Series championship with Greg Biffle
2000: Won NASCAR Craftsman Truck Series with Greg Biffle

I have been fascinated by engines my entire life. Having the opportunity to race them is a challenge that I enjoy. As a young boy, I had model airplanes and have always been fascinated by flying.

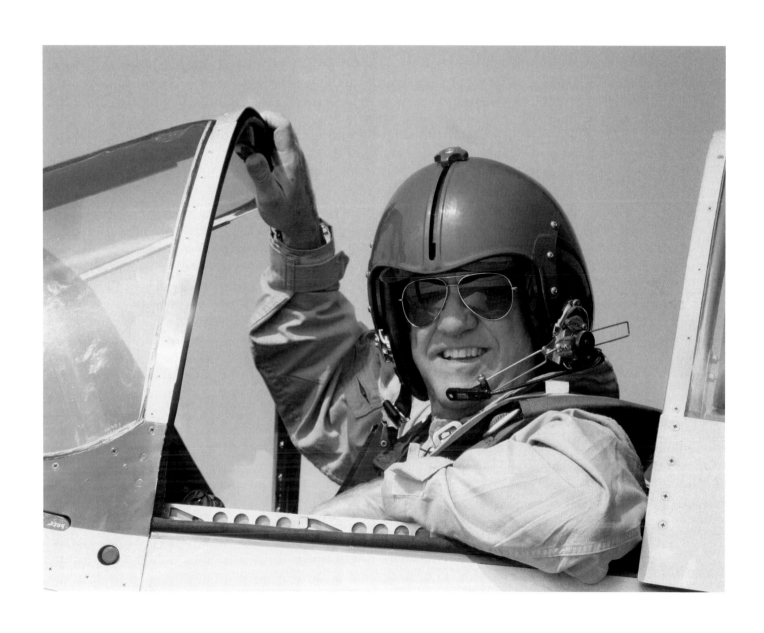

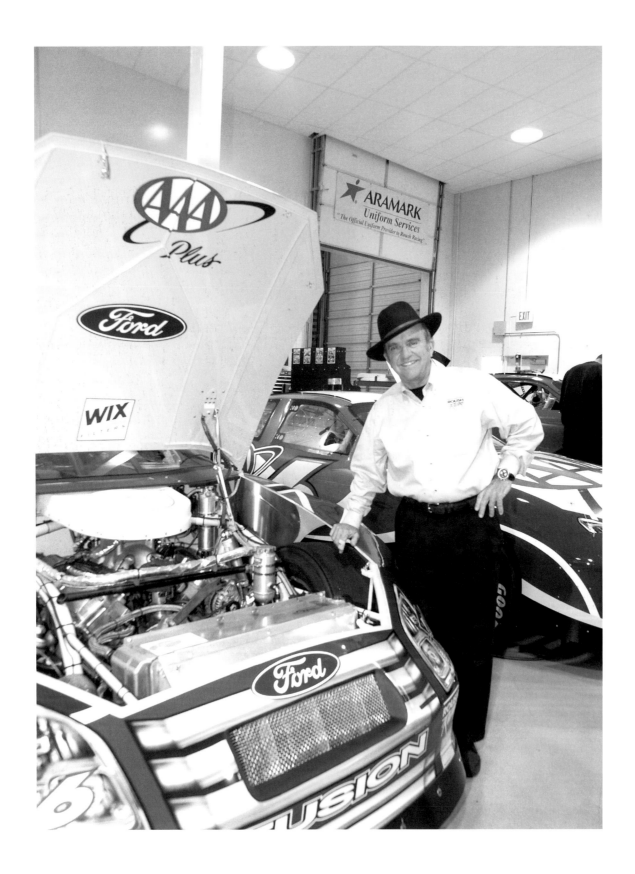

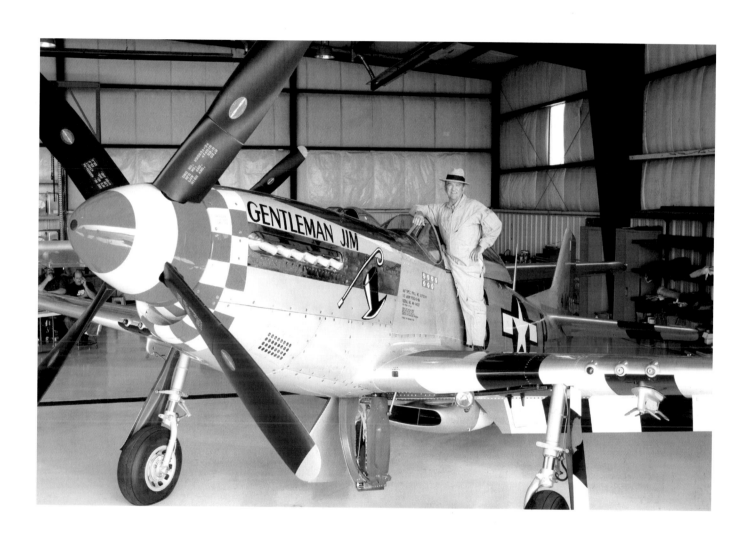

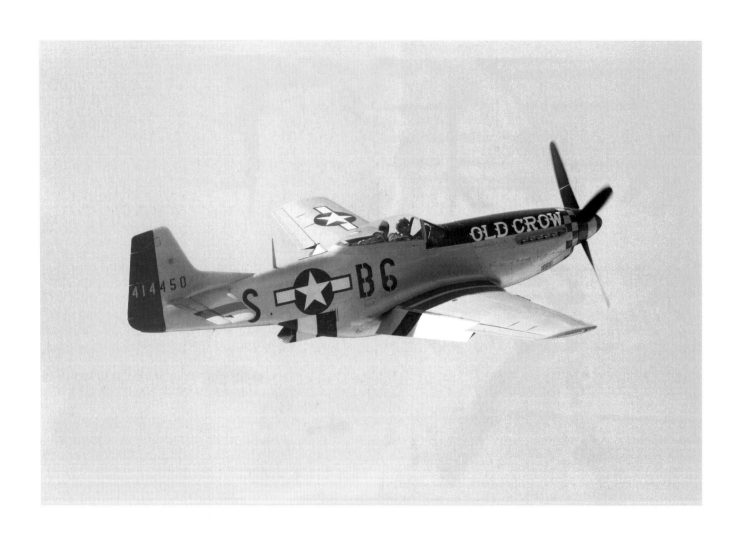

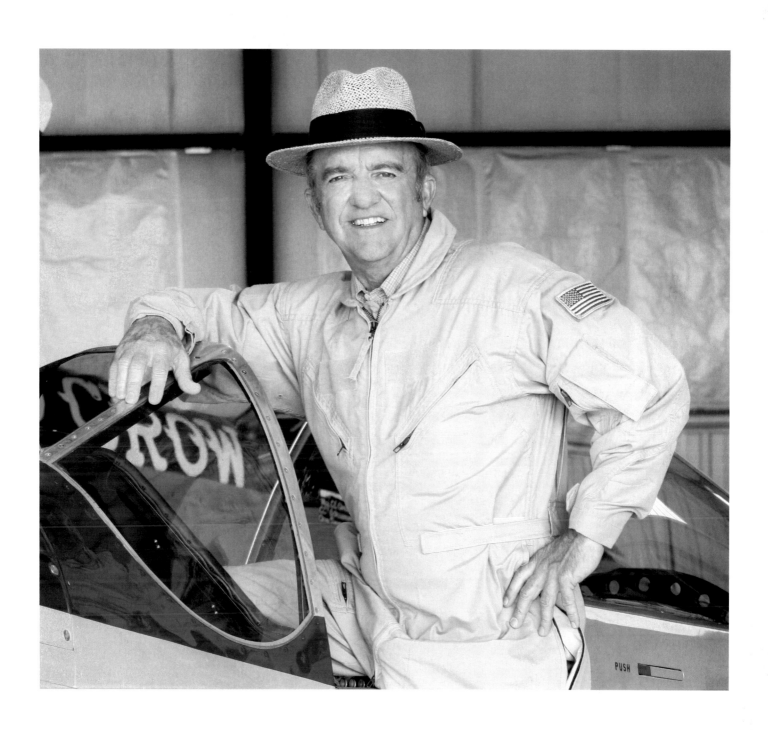

ELLIOTT
SADLER

Birthdate: April 30, 1975
Birthplace: Emporia, Virginia
Residence: Emporia, Virginia
Family and Personal: Single; son of Bell and short-track driver
Herman Sadler; nephew and namesake of short-track driver Bud
Elliott; brother of NASCAR Sprint Cup Series driver Hermie Sadler

Career Highlights

2004: Earned a spot in the Chase for the NASCAR Sprint Cup
2001: First NASCAR Sprint Cup Series victory, Food City 500
 at Bristol
1995: Track Champion, South Boston Speedway in Virginia

There is more to life than letting it race by you. My parents are my biggest inspiration. We all gather at the Barn, with our friends and community.

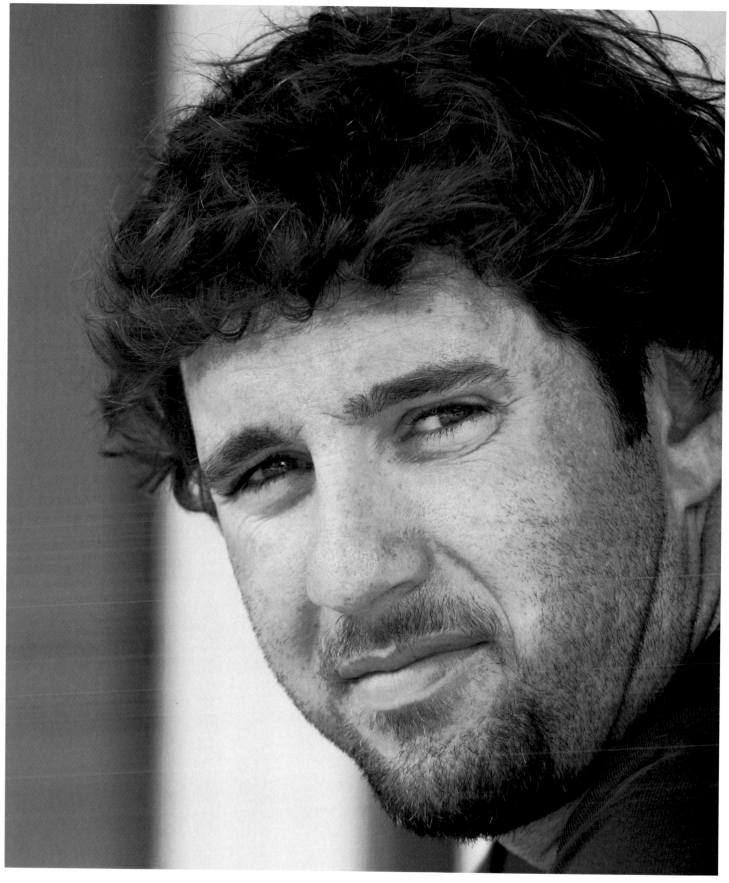

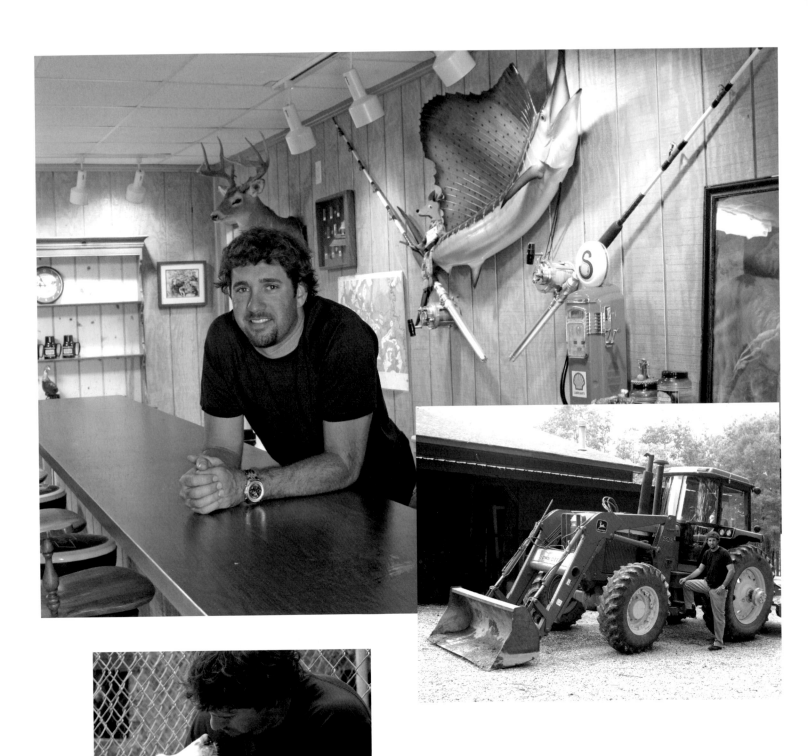

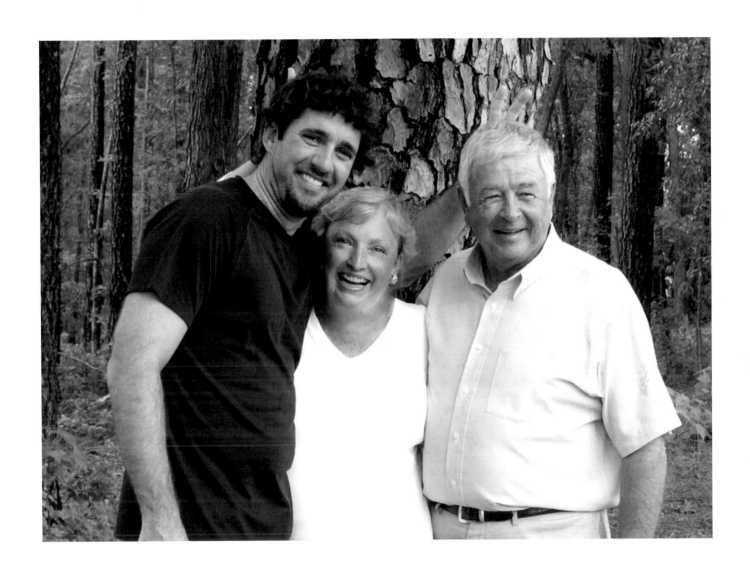

TONY
STEWART

Birthdate: May 20, 1971
Birthplace: Columbus, Indiana
Residence: Columbus, Indiana
Family and Personal: Single

Career Highlights

2006: IROC Champion
2005: NASCAR Sprint Cup Series Champion
2002: NASCAR Sprint Cup Series Champion
1999: NASCAR Sprint Cup Series Raybestos Rookie of the Year
1997: IRL Champion
1996: IRL Rookie of the Year
1991: USAC Rookie of the Year

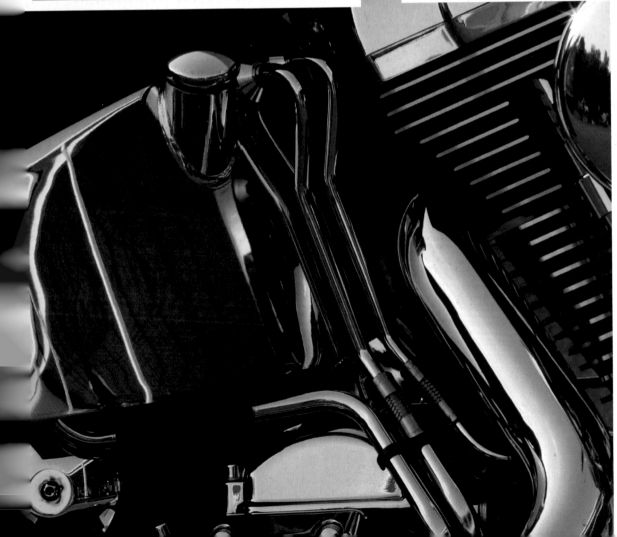

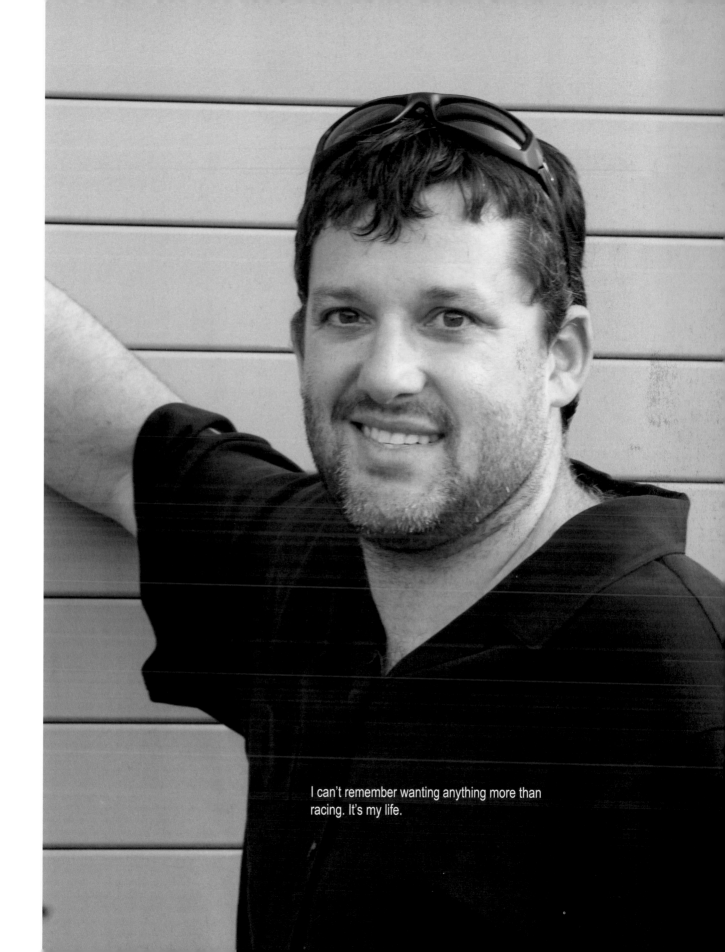

I can't remember wanting anything more than racing. It's my life.

MARTIN
TRUEX JR.

Birthdate: June 29, 1980
Birthplace: Mayetta, New Jersey
Residence: Mooresville, North Carolina
Family and Personal: Single; son of racer Martin Truex Sr.

Career Highlights

2007: First NASCAR Sprint Cup Series victory, Autism
Speaks 400 at Dover
2005: NASCAR Nationwide Series Champion
2004: NASCAR Nationwide Series Champion, rookie year

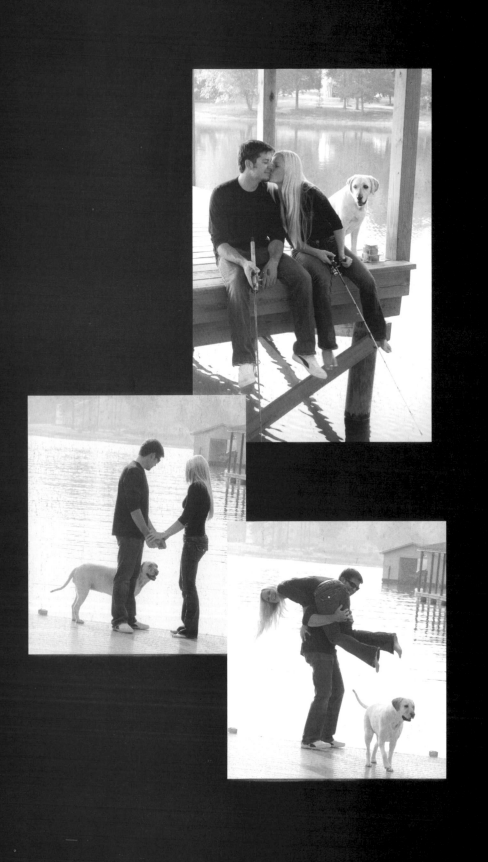

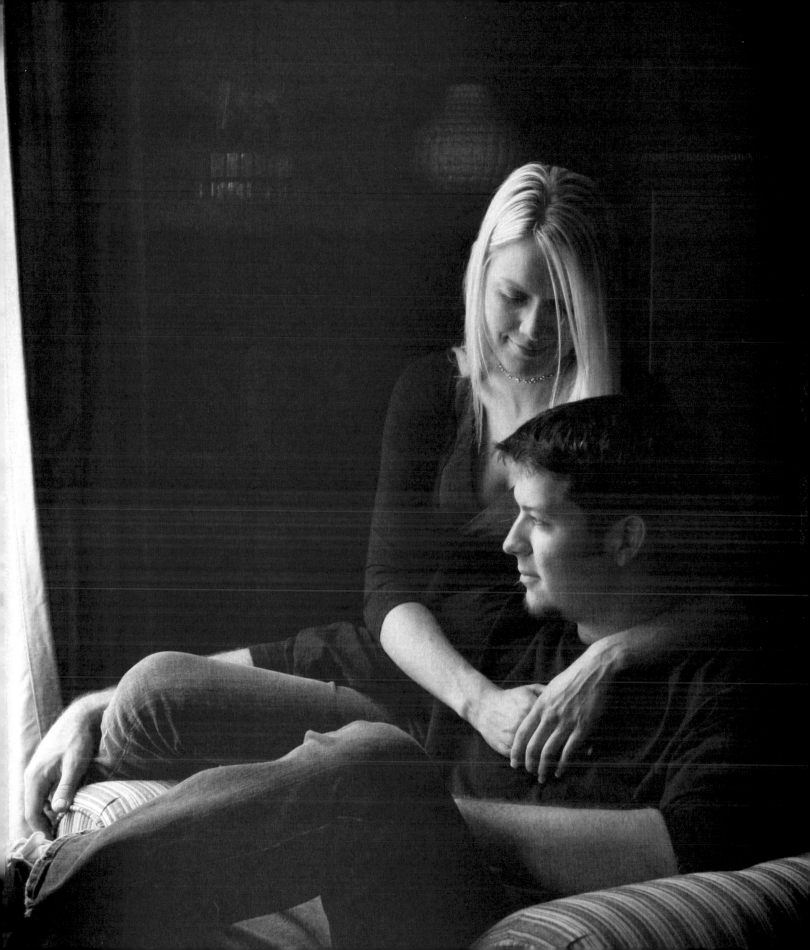

BRIAN VICKERS

Birthdate: October 24, 1983
Birthplace: Thomasville, North Carolina
Residence: Charlotte, North Carolina
Family and Personal: Single: Son of Ramona and Clyde Vickers;
brother of Melissa; brother-in-law of Keith; uncle of Davis and Thomas
Bryant

Career Highlights

2006: First NASCAR Sprint Cup Series victory, UAW-Ford
500 at Talladega
2003: NASCAR Nationwide Series Champion, rookie year
2000: USAR ProCup Series Rookie of the Year

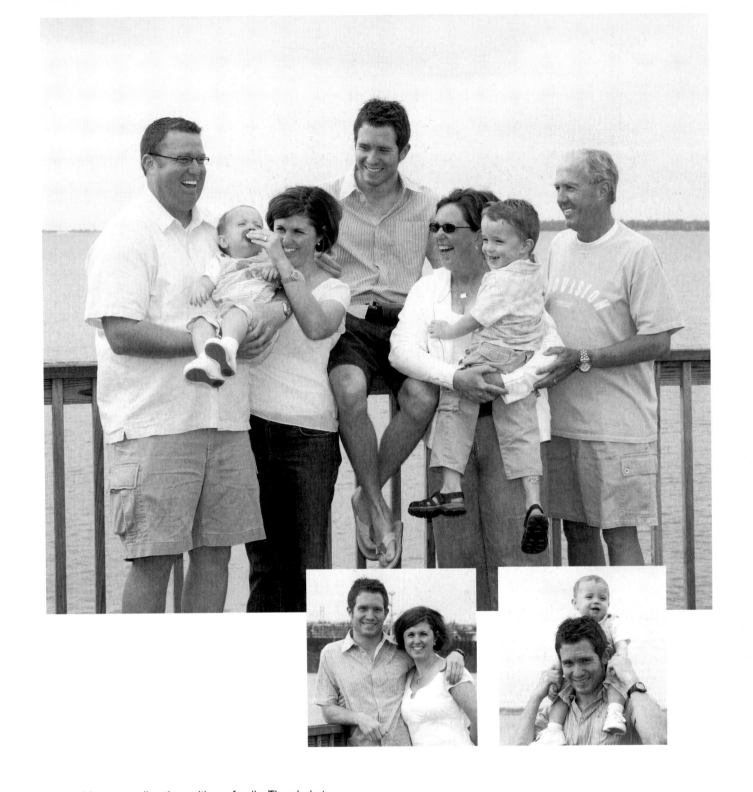

I love spending time with my family. They help to
keep me grounded.

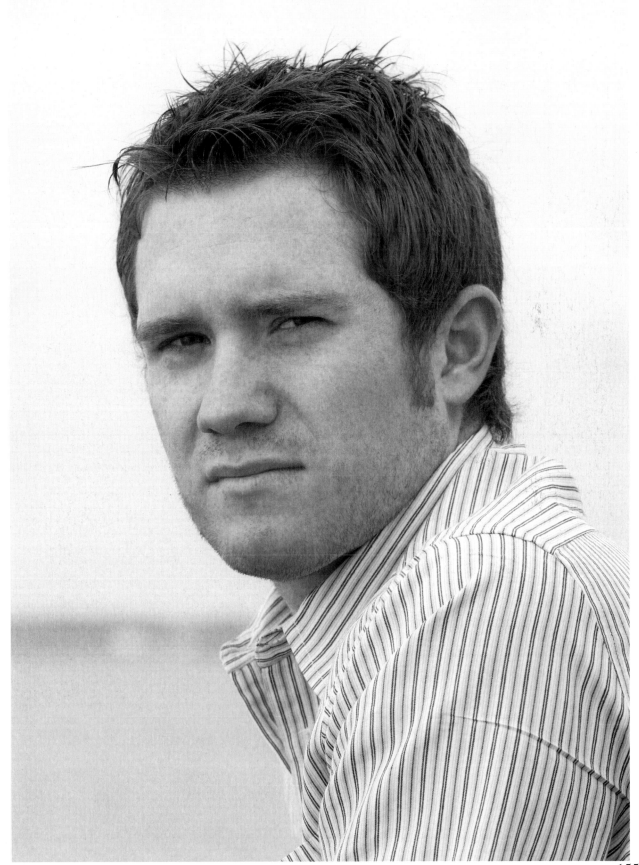

RUSTY
WALLACE

Birthdate: August 14, 1956
Birthplace: St. Louis, Missouri
Residence: Cornelius, North Carolina
Family and Personal: Married to Patti; father of Greg, Katie, and Steve; race analyst, ABC/ESPN; owner, Rusty Wallace Inc., which includes the No. 64 NASCAR Nationwide Series team, Diamond Aviation, RWI Promotions, and track-design business

Career Highlights

1998: Named one of NASCAR's 50 Greatest Drivers of All Time
1991: IROC Champion
1989: NASCAR Sprint Cup Series Champion
1984: NASCAR Sprint Cup Series Raybestos Rookie of the Year
1983: ASA Champion
1979: USAC Rookie of the Year

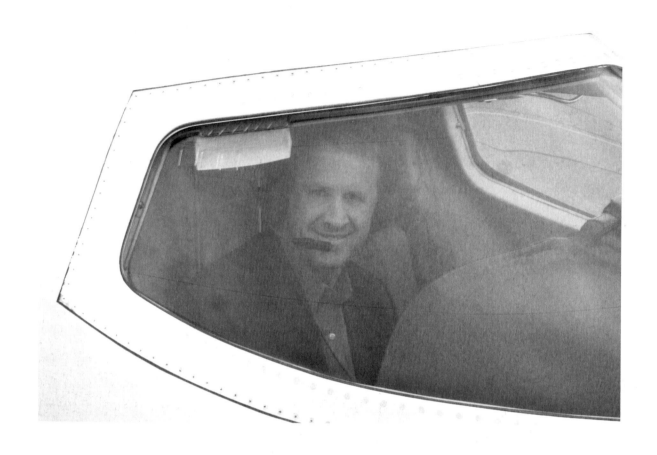

Like racing, flying is my passion. Whenever I get to
travel with my family, it gives me a chance to talk to
them about the things going on in our lives.

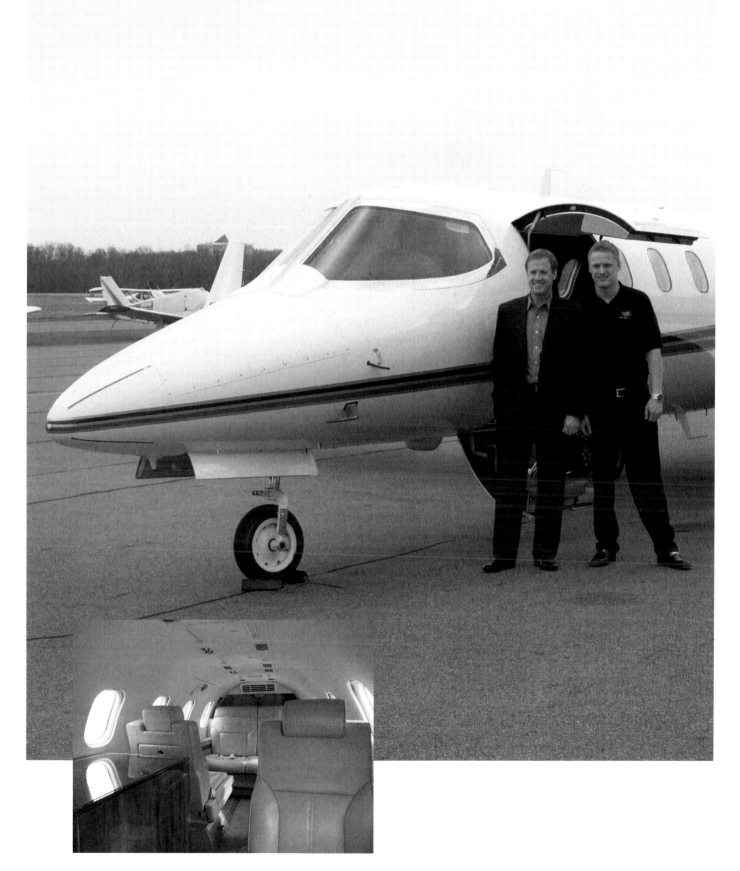

MICHAEL
WALTRIP

Birthdate: April 30, 1963
Birthplace: Owensboro, Kentucky
Residence: Sherrill's Ford, North Carolina
Family and Personal: Married to Buffy; father of Caitlin and Macy; brother of three-time champion Darrell Waltrip; owner, Michael Waltrip Racing, which includes three NASCAR Sprint Cup Series teams (Nos. 44, 55, and 00), two NASCAR Nationwide Series teams (Nos. 99 and 00), and the No. 99 USAR team

Career Highlights

2001 and 2003: Daytona 500 Winner
1983 and 1984: NASCAR Dash Series Most Popular Driver
1983: NASCAR Dash Series National Champion

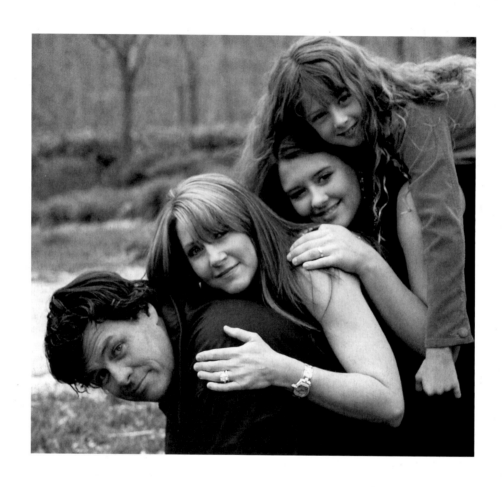

We are blessed, always there for each other. I love
being with my girls.

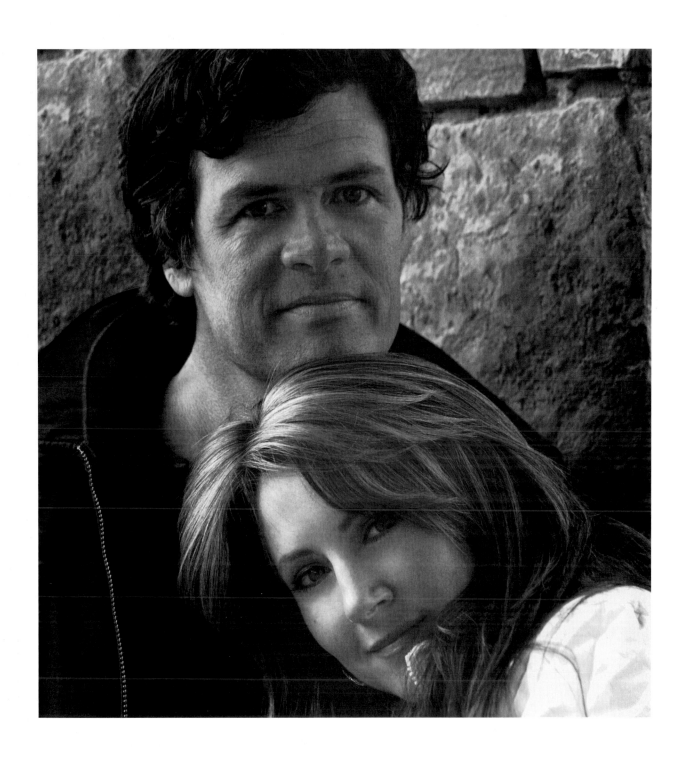

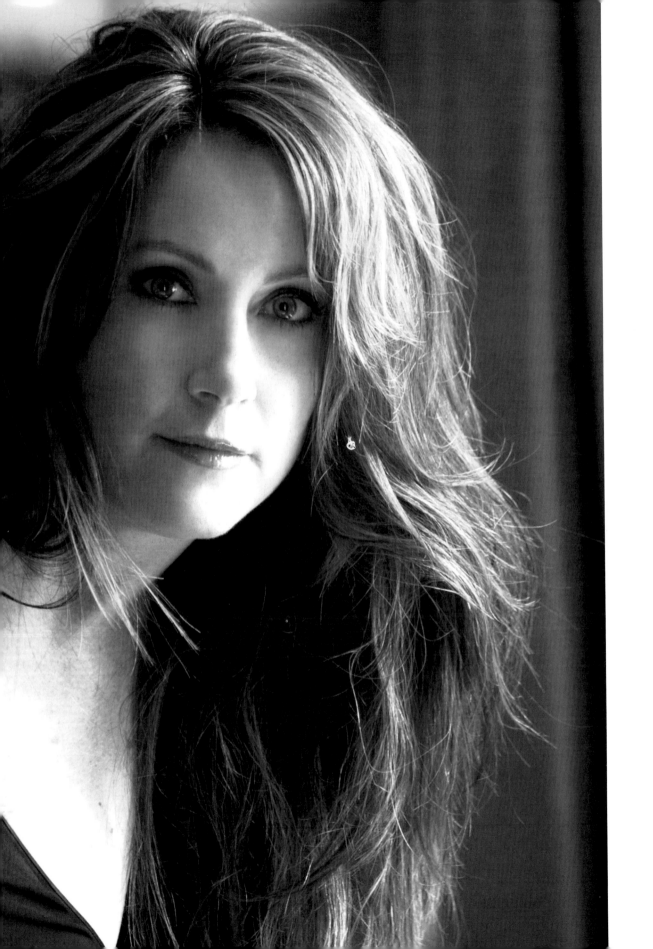

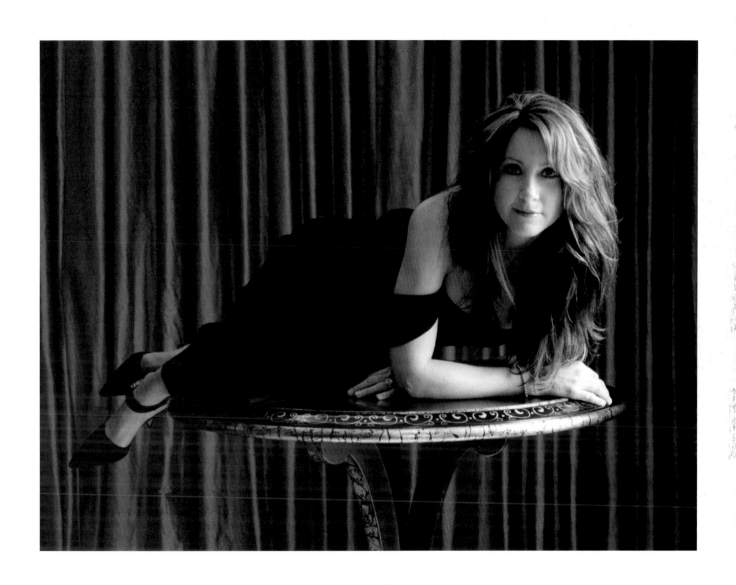

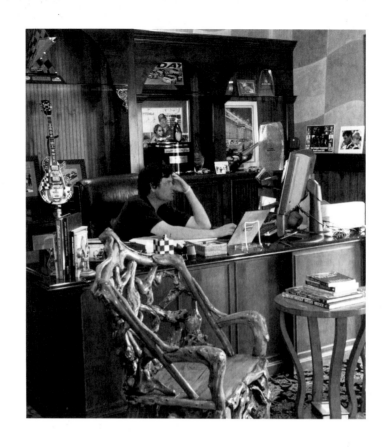

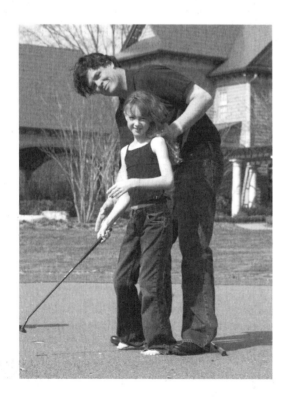

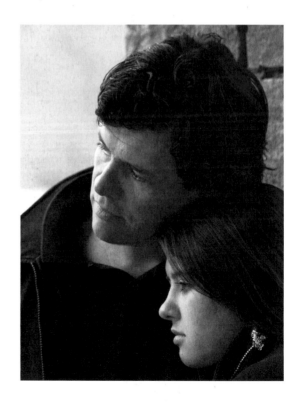

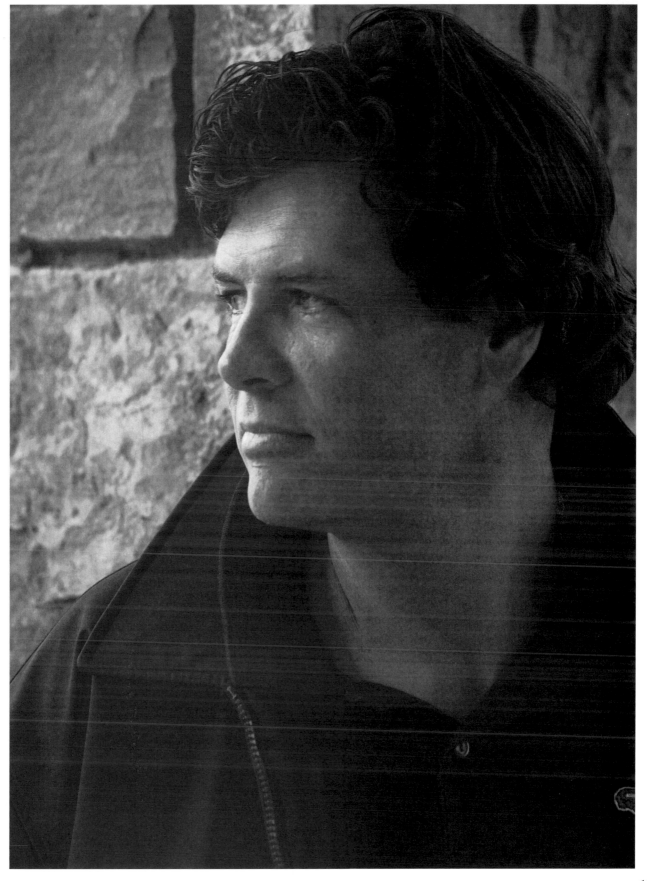

HUMPY
WHEELER

Birthdate: October 23, 1938
Birthplace: Belmont, North Carolina
Residence: Charlotte, North Carolina
Family and Personal: Married to Pat; father of Patti, Tracy, and Trip; grandfather to Jack and Adele Marchant and Austin and Adam Hardy

Career Highlights

2006: Inducted into International Motorsports Hall of Fame
2006: Provided the voice for "Tex," a 1975 Cadillac Coupe de Ville in the Pixar film *Cars*
1975: Hired by Bruton Smith at Charlotte (now Lowe's) Motor Speedway. Named General Manager in 1976 and President in 1980
1960s: Director of Racing, Firestone Tire and Rubber Company

Racing is very intense for all of us. Working out helps me cope with stress and energy levels. My wife Pat and I have a lot of fun together, particularly around the serenity of water.

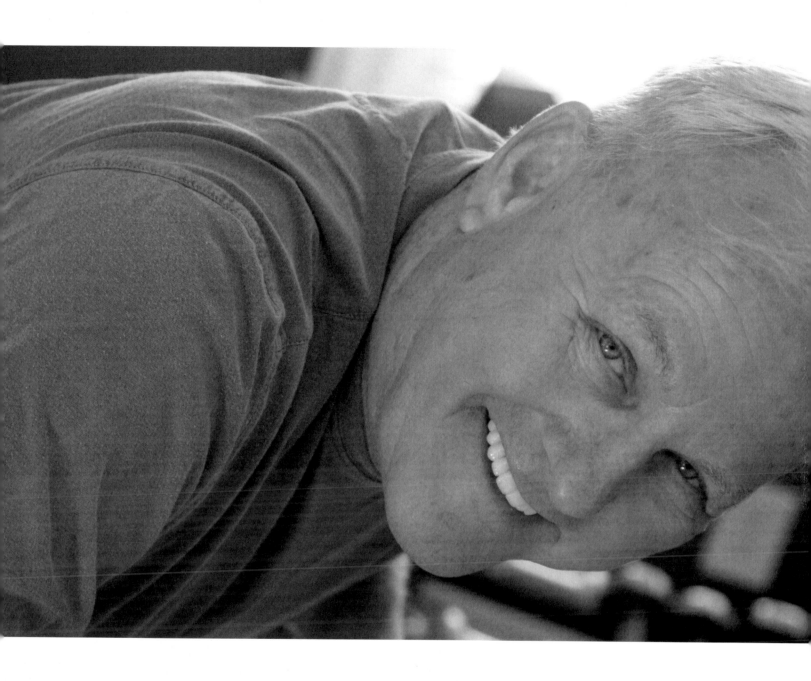

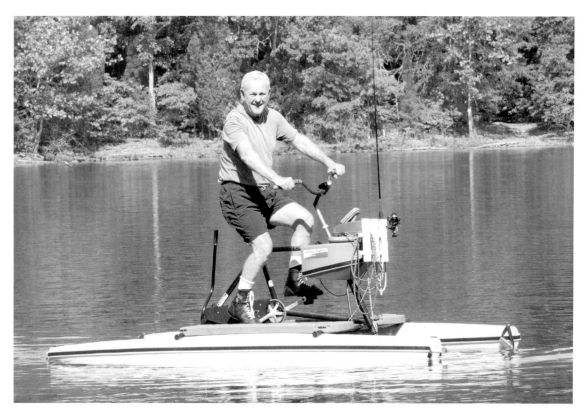

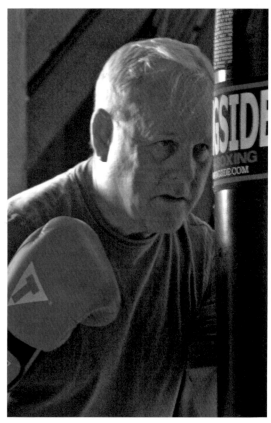

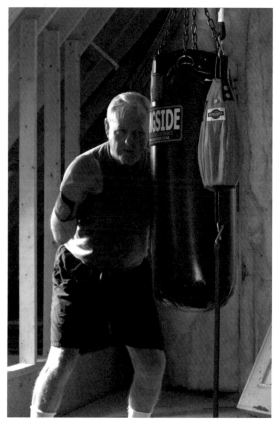

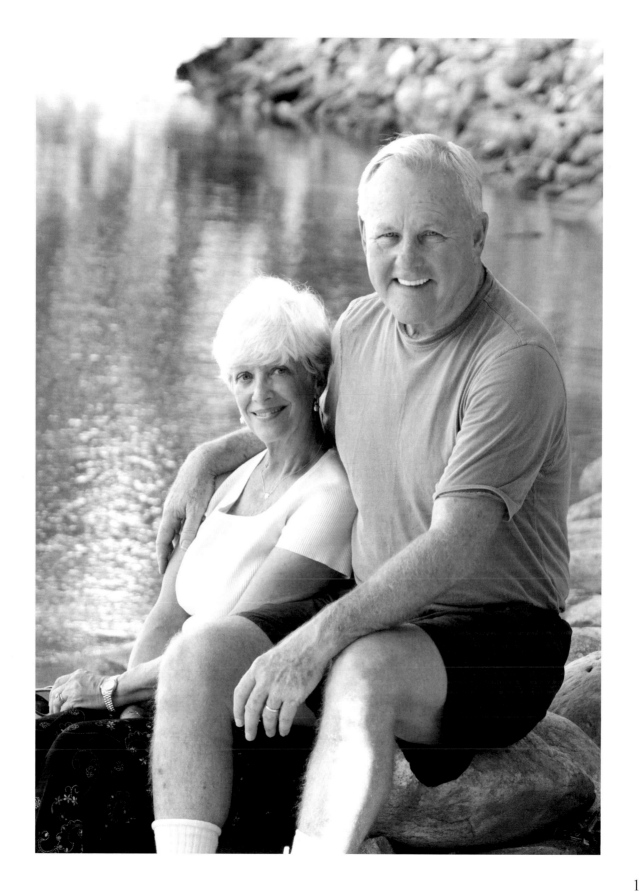

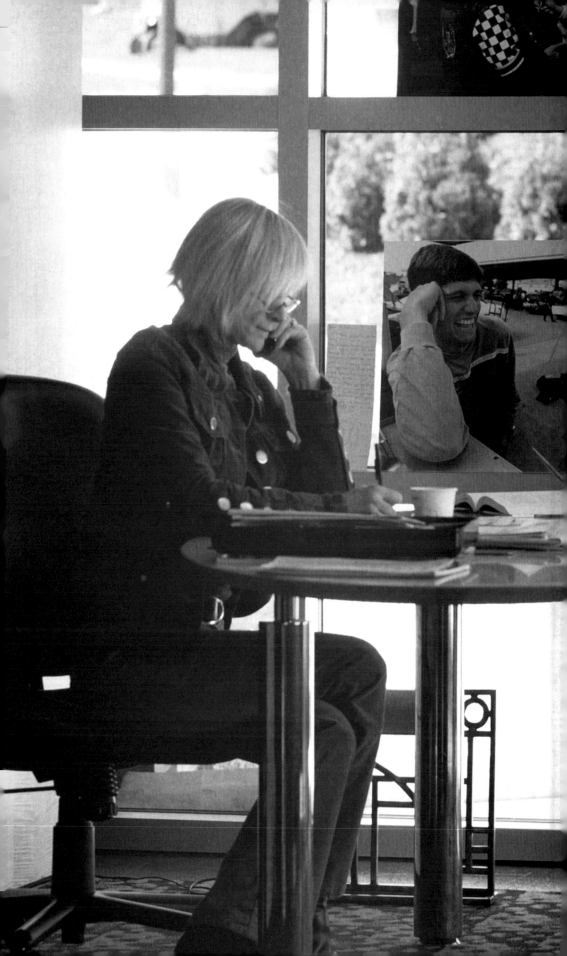

VICTORY JUNCTION GANG CAMP

Our greatest desire is to give hope and a joyful memory to our special children. We appreciate and thank everyone that contributes to the success of The Victory Junction Gang Camp.

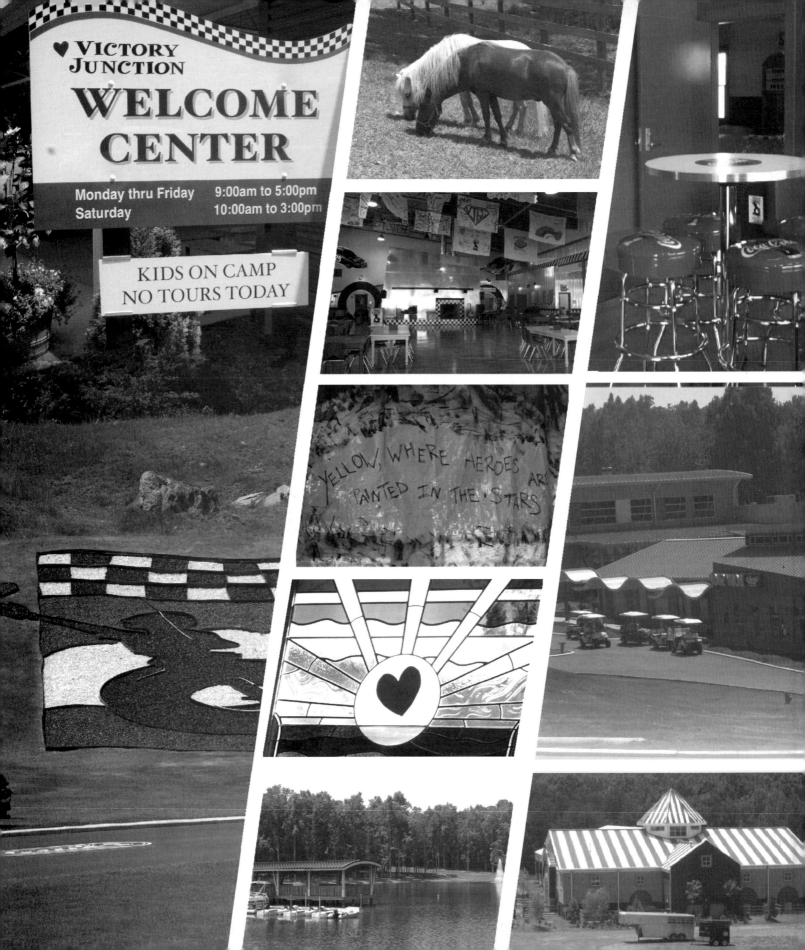

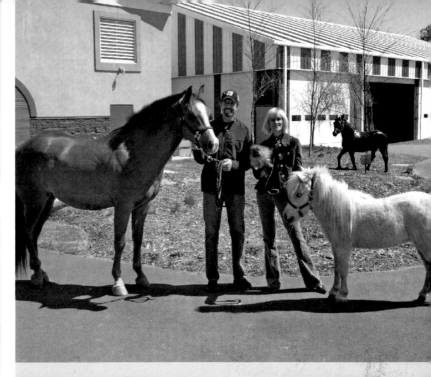

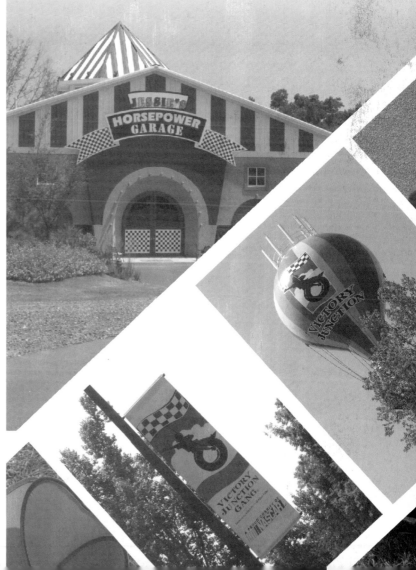

WAM

WOMEN'S AUXILIARY OF MOTORSPORTS

Mission is to enrich the lives of women, children, and families through educational and wellness programs

Helps support organizations with likeminded missions and purposes, including Motor Racing Outreach, The Susan G. Komen Breast Cancer Foundation, Victory Junction Gang Camp, and Stocks for Tots

Established in 2004 with the merger of the Winston Cup Racing Wives Auxiliary and the Busch Series Ladies Association

In 2004 designated a part of The NASCAR Foundation Family of Charities.

Exists on fundraising projects as well as donations

Donated $200,000 for the building of the playroom at the Jeff Gordon Children's Hospital

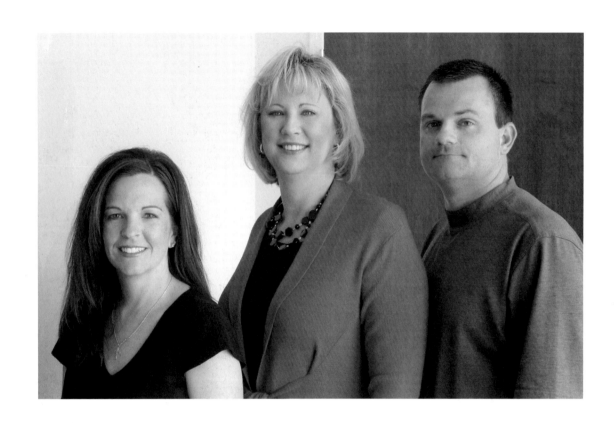

Our mission is to enrich the lives of women,
children, and families through wellness programs.
Family is a crucial part of our sport.

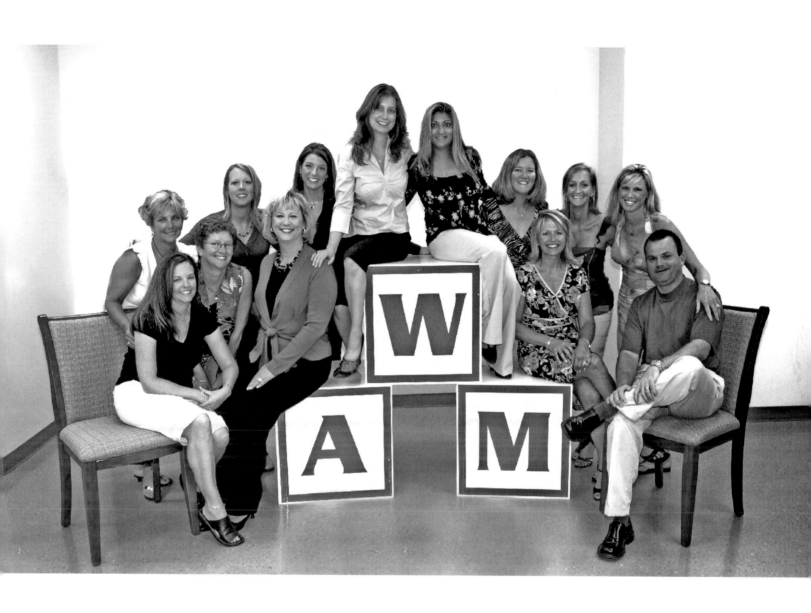

ABOUT THE AUTHORS

Anita and Robin first met through their children at school, and their friendship quickly developed. While Anita's first introduction into the world of motorsports came when she moved to Kannapolis, North Carolina in 1997, Robin has been in the racing community practically all of her life.

Anita became curious about the real lives, and the families, of the drivers and other personalities, and was excited with her vision that an artistic black-and-white coffee table book could bring this unique view to the rapidly growing base of racing fans. In 2005, she flew to Texas and met with Robin to discuss her vision, and did the first photo shoot for the book. Robin's enthusiastic response prompted them to join together, and the *Portraits of NASCAR* project was born.

Over the next 2 years, Robin used her extensive knowledge, connections and friendships within the racing community which was the access to the stars and personalities in the sport. She was a familiar face to put them at ease during the photo shoots and interviews. Anita put her artistic talents to work shooting the photographs, creating the layouts, and designing the book. Anita and Robin have worked closely together on the project, supported each other, and consulted on management and direction together.